Slipcasting

shown below.

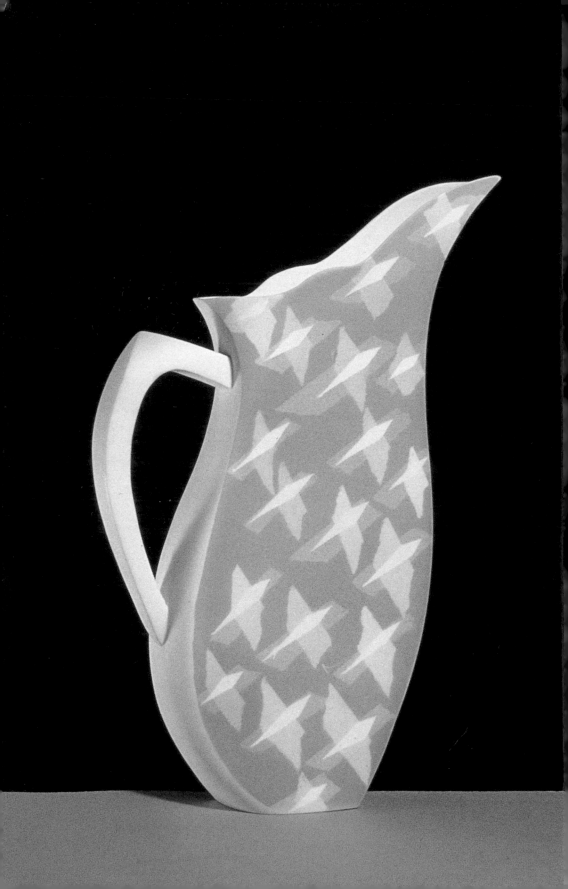

SLIPCASTING

Sasha Wardell

A & C Black · London

First published in Great Britain 1997 by
A & C Black (Publishers) Limited
35 Bedford Row
London WC1R 4JH

ISBN 0-7136-4067-7

A CIP catalogue record for this book is available from
the British Library.

Cover illustrations
front Bone china vase and stand by Sasha Wardell,
1994, h. 38 cm. *Photograph by Mark Lawrence.*

back Bone china vase by Caroline Harvie. *Photograph
by John Bisset.*

Frontispiece
Bone china jug by Sasha Wardell, 1988, h. 21 cm.
Photograph by Stephen Brayne.

Design by Alan Hamp

Filmset in 10/12 Photina by August Filmsetting,
Haydock, St Helens
Printed in Hong Kong by Wing King Tong Co Ltd

Contents

	Acknowledgements	6
	Preface	6
	Introduction	7
1	**Plaster – The material**	11
2	**Tools and materials**	18
3	**Modelmaking**	25
4	**Mouldmaking Part I**	46
5	**Mouldmaking Part II**	58
6	**Slipcasting**	71
7	**Bone china**	85
8	**Individual approaches**	101
	Appendix	122
	Glossary of terms	124
	Bibliography	126
	Suppliers	127
	Index	128

Preface

In the field of ceramics, the responsibility for the all-pervading bad taste of the last century and the very probable 90% bad taste of today lies mainly with machine production and the accompanying indifference to aesthetic considerations of individual industrialists and their influence on the sensibility of the public.

From Bernard Leach's *A Potter's Book*

Sadly over the years slipcasting has received a bad press giving rise to an undervaluing of the technique. No doubt, Leach had good reason to believe this when confronted with badly-considered forms which were made from a purely economical and labour-saving viewpoint. However, when this technique is used in conjunction with sensitive and creative design, it can become a satisfying and useful vehicle for realising a broad spectrum of exciting ceramics. Hopefully, this manual will help to encourage ceramicists, both students and professionals alike, to experiment and understand the possibilities opened up by slipcasting and its accompanying techniques.

Acknowledgements

First of all, I would like to thank all the ceramicists who have so readily given information and whose works feature in this book. In particular, I wish to extend thanks to the following people whose contribution has been invaluable in its preparation:

Kathy Niblett of Stoke City Museum, Jane Gibson and staff at Bath College of Higher Education, Harry Fraser of Potclays, J. B. Green of British Gypsum, Alma Boyes, Sarah Richards, Steve Hook, Ron Adams, Mark Lawrence and John Law.

In addition to this, I would like to mention the help, support and encouragement given by Julie and Guy Channer and my editor Linda Lambert.

Introduction

Brief technical description of slip casting

Definition of **Slip**: Suspension of clay in water

Definition of **Casting**: Forming pottery by pouring slip into porous moulds. On emptying, an even layer of slip coats the interior of the mould.

Principle of casting: A dry porous mould is filled with liquid clay or slip. The capillary action of the plaster removes a high proportion of the water from the slip adjacent to it resulting in a layer, or skin, of clay being built up on the inner surface of the mould. This remains when the surplus slip is emptied. The thickness of this layer, or cast, is determined by the length of time the slip remains in the mould.

Brief historical background on the development of slipcasting and the use of plaster in the production of ceramics

Before the discovery of plaster of Paris for use in moulding, the Chinese used biscuited clay moulds which were fairly porous and very durable. Porcelain was one of the chief clays to be used in this way, for by its nature, it is a very smooth clay and so able to pick up any fine detail.

Plaster's general properties have been known since at least 2 500BC when the ancient Egyptians used it to fill the joints of the Great Pyramid. They also used it to make death masks and for casting parts of the human body. The ancient Greeks were also using it as far back as the 5th century to make one-piece pressmoulded forms, and the Chinese used it on the Ming Chi funeral figures of the pre-Tang era.

The principle of slipcasting.

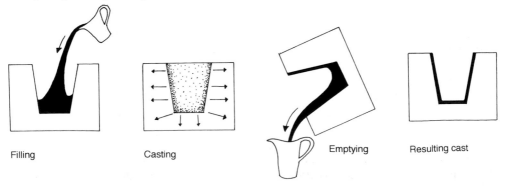

Filling Casting Emptying Resulting cast

Later on, the Greeks used it to take casts of statues and in Italy, Renaissance artists not only sculpted in plaster but they also made plaster moulds to copy originals.

The name 'plaster of Paris' came about due to the discovery of gypsum deposits at Montmartre in Paris during the Middle Ages. However, it was not until the the mid-1700s that it was first commercially mined and this paved the way for a material which was to be used in the production of ceramics. Its use in making moulds and the technique of slipcasting developed as it became known that a properly made and dried mould is microcellular. This means that by capillary action it will absorb water held in suspension in the clay and support the cast until it is dry enough to be handled and subsequently fired.

According to A.E. Dodd in his 'Notes on the Early Use of Plaster and Slip Casting' in the *Journal of the British Ceramic Society* (1969, vol. vi), the first use of plaster in the British pottery industry is generally attributed to Ralph Daniel of Cobridge, Stoke on Trent around 1745. Simeon Shaw, in his history of the Staffordshire Potteries writes:

> Mr. Ralph Daniel of Cobridge happened to visit a porcelain manufactory in France, where, among other information relative to their process, he ascertained that the moulds were formed by mixing Plaster of Paris in a pulverulent state with water. He obtained a mould of a large Table Plate, which on returning home he exhibited to all the Potters and explained the discovery, and its attendant advantages, and quickly moulds were introduced. The manufacturers were eager to possess

moulds because of the numerous productions which with great facility could be formed in them, yet not be produced by the wheel and the lathe.

Before slipcasting was developed throwing, jigger and jolleying and pressing were the main methods of manufacture. The throwing of pots on a wheel meant the potter dictated the shape of the pot entirely by his hands. Inevitably this meant there was some variation between each piece and so the technique of jigger and jolleying was introduced to speed up the operation and allow for repeatable shapes.

'Jolleying' is normally the term used for hollow-ware, i.e. bowls, cups etc. and 'jiggering' is the term used for flatware i.e. saucers, plates etc. Originally, in the case of jolleying a bowl, this technique involved a revolving mould which formed the outside surface. As the mould revolved, a lump of clay was placed in the mould and a hand-held template, originally made from a piece of slate, was placed in the mould forming the inside profile of the clay bowl. With jiggering plates or saucers, the mould formed the inside or top surface of the piece and the outside, or back surface, of the piece was formed using a hand-held profile, a sheet of clay having been placed onto the mould prior to it revolving. The principle of this technique has not greatly changed except for the development of automated or semi-automated templates made from zinc or similar metals.

Pressing was usually used for all the shapes that were unsuitable for throwing or jolleying and particularly for handles, spouts and knobs etc. This method reached a very high standard of achievement during the late 18th and early 19th centuries when it was possible to make more intricate and

complex shapes using plaster piece moulds. Each piece of the mould would be worked individually. A sheet of clay would be laid across the mould and the presser would carefully press the clay into every exterior surface of the mould with a sponge, modelling as he went, the interior of the piece. Occasionally, he would add more clay where strength was required, or take clay away if necessary. Once all the pieces were completed, the clay impressions would be assembled by 'luting' (a method of joining clay using water and clay in a slurry) and sponging down the edges. At that time slipcasting was the least common of these basic methods as it was mainly confined to the porcelain factories where it appeared to be the only way to make pots which were made from intractable, high shrinkage clays.

The development of deflocculated casting slips

In the mid-18th century casting was done with a 'water slip' which was a combination of the clay body and water mixed to a pourable consistency but it wasn't until the 2nd half of the 19th century, with the discovery of deflocculated slips, that slipcasting became an important manufacturing method for the production of hollow-ware.

There were three main disadvantages with a 'water slip'. One is the high water content which resulted in completely saturated moulds and therefore total

drying of the moulds between each cast was necessary. Secondly, the water-soaked capillaries in the mould drastically reduced the working life of a mould and, thirdly, the high water content meant a very high cast shrinkage resulting in distortion and consequent loss.

To remedy this a solution was needed whereby the water content could be reduced while still maintaining fluidity. According to A.E. Dodd, the first reference he has been able to trace as the original use of a deflocculated slip is in Alexandre Brongniart's *Traité des Arts Céramiques*. Here he mentions a Frenchman, M. Bettignies, who added 3% of potassium carbonate to a soft-paste porcelain slip in his factory at Tournay in Belgium. It is described as 'to give the necessary bond to ensure its adhesion to the mould'. According to Brongniart, slipcasting was first used in France *c.*1790 by a Monsieur Tendelle in conjunction with the manufacture of porcelain and by 1814 slipcasting was introduced at Sèvres.

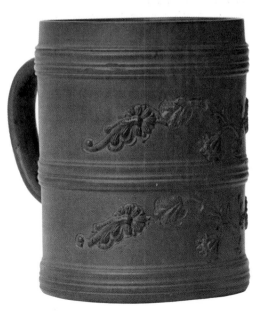

Slipcast mug in red stoneware with mould applied relief decoration and turned bands by the Elers Brothers, Bradwell, nr. Newcastle-under-Lyme, 1693–1696. *Courtesy of City Museum and Art Gallery, Hanley, Stoke- on-Trent.*

9

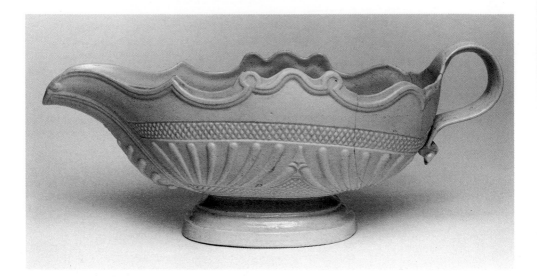

In England, the Elers brothers produced the first examples of slipcast ware using a water slip in a small pottery at Bradwell near Newcastle-under-Lyme between 1693–1696 where they produced red stoneware bowls, mugs and teapots. Other examples of early slipcast pieces were found between 1750–1755 when Bristol and Worcester were making sauce boats with relief decoration using water slips. The introduction of white salt-glaze stoneware sauceboats from 1750–1770, originating from the German potters, was another example of early slipcast ware made in Staffordshire.

As previously mentioned, the water slips were not very satisfactory and so, for the rest of the century, pressmoulding returned as the main method of

Slipcast sauceboat, white salt-glazed stoneware made in Staffordshire, 1750–1770. *Courtesy of City Museum and Art Gallery, Hanley, Stoke-on-Trent.*

manufacture until deflocculated slips were developed and stabilised. This, coupled with the introduction of plaster of Paris into North Staffordshire in 1745 meant that slipcasting ran concurrently with the other methods described above as one of the main methods of ceramic manufacture in England.

Around this time on the Continent elaborate and complex multi-part moulds producing porcelain figures were found in the European factories of Meissen and Nymphenburg in Germany and at Vincennes and later at Sèvres in France.

Chapter One
Plaster – the Material

Technical information

Plaster is derived from a partially dehydrated mineral called gypsum. This is a widely distributed rock which results from the evaporation of salt water. It is made up of hydrated calcium sulphate ($CaSO_4$ $2H_2O$), and originates from shells embedded in clay which are attacked by sulphuric acids (from metallic sulphides) and are then turned into gypsum crystals. The pure microcrystalline form is alabaster.

Initially, the gypsum has to be quarried, screened and pulverised after which it is calcined in a revolving cylinder to 120°C. During this process the gypsum loses more than $\frac{3}{4}$ of its water of crystallisation and becomes an unstable demi-hydrate ($CaSO_4$ $\frac{1}{2}$ $2H_2O$). Thus the plaster is left in a state of perpetual thirst. This explains its affinity for water – plaster is often described as hydroscopic or water-seeking. When combined with water, it rehydrates to form a soft porous stone termed plaster of Paris.

Characteristics and properties of plaster

Homogeneity

After preparation plaster possesses certain properties one of which is homogeneity. This means that when properly mixed with water and allowed to crystallise, plaster becomes solid with no grain, nor hard or soft spots. This makes it an ideal material for working with, whether carving by hand, turning on a lathe or scraping with a template.

Predictability

Once a given plaster-water ratio is known for a particular type of plaster, then batch after batch can be mixed and each mould will be consistent in its water-absorbing properties.

Expansion or swell

When plaster is mixed with water and crystallisation takes place, it expands slightly. This property is very useful in model and mouldmaking. However, it needs to be considered and fully understood to avoid problems which can occur. For example: (a) When making a mould from a plaster model, and therefore pouring plaster over plaster, the swell away from the object will facilitate easy release; and (b) When pouring plaster into a plaster mould, the swell against the sides prevents the removal of the model therefore splitting the mould off is the only solution (see Chapter 5).

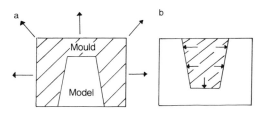

Swell and expansion of plaster.

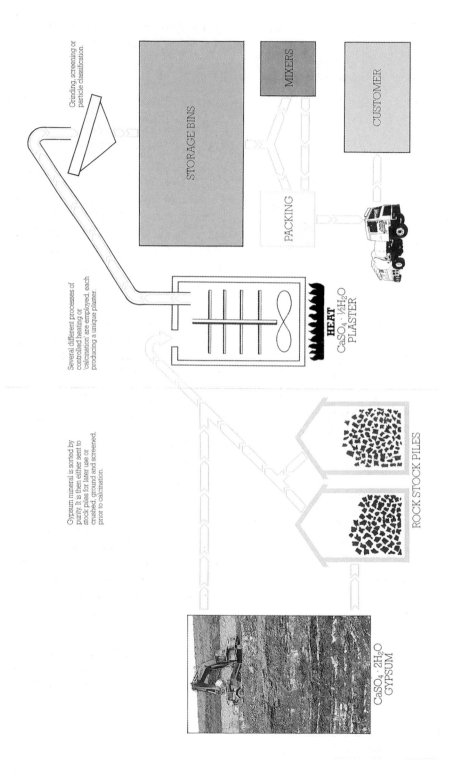

Grinding, screening or particle classification.

STORAGE BINS

MIXERS

CUSTOMER

PACKING

Several different processes of controlled heating or calcination are employed, each producing a unique plaster.

HEAT
CaSO$_4$ · ½H$_2$O
PLASTER

Gypsum mineral is sorted by purity. It is then either sent to stock piles for later use or crushed, ground and screened, prior to calcination.

ROCK STOCK PILES

CaSO$_4$ · 2H$_2$O
GYPSUM

How plaster is obtained from gypsum.
Courtesy of British Gypsum.

Economical

Plaster is a relatively inexpensive material and, since it is impossible to reclaim, waste need not be a major concern. Experience, however, on calculating amounts reduces waste to a certain extent and the use of 'moulding bats' is a handy addition to any plaster workshop (see page 17 for making method).

Plaster types and storage of dry plaster

British Gypsum is the main supplier in the U.K. They produce several types of plaster of which the following have been adapted to suit individual needs in the ceramic field:

Pottery plaster (setting time 15–30 minutes)

A general plaster which can be used for both model and mould making once adjustments have been made to alter the plaster – water ratios (see overleaf). It is off-white in colour but can have pink or grey colouring for cast ware, sanitary ware, jolleyed or hand-pressed ware and working moulds to differentiate between them in an industrial situation.

Ultramix (setting time 10–20 minutes)

A buff-tinted plaster normally used in the manufacture of master and case moulds (see Chapter 5).

Keramicast (setting time 15–30 minutes)

An off-white plaster which can have pink or grey colouring. It is useful for higher strength working moulds, particularly with automatic forming equipment in industry.

Fine Casting

A basic casting plaster. It is off-white in colour and can have slightly pink or grey shading. Of medium hardness, it can be easily carved and turned.

Superfine Casting

A basic casting plaster with a consistent white colour; a standard for making white articles. Slightly harder than Fine Casting but also suitable for carving and turning.

Helix

A plaster with good strength which is off-white in colour and can have a slight pink or grey shading. Suitable for general casting and building up structures.

Herculite Number 2

A hard white plaster for use where colour, high strength and surface durability are required.

Crystacal R

An extra hard white plaster for use where high strength and surface hardness are important. Longer working than Herculite No. 2 with a lower expansion on setting.

Herculite Stone

Longer working than both Herculite No. 2 and Crystacal R, with high set strength and relatively low expansion. Off-white in colour.

Crystacast

An exceptionally hard plaster for use where a fluid mix is required in conjunction with great strength and surface hardness.

Newcast plasters

A new range which has been developed to meet competition from foreign plaster manufacturers. There are four types of Newcast used in slipcasting (for particular details contact British Gypsum). It is used for producing moulds with good permeability coupled with a longer working life. The mould wear is very slow and uniform thus allowing production of good quality clay casts throughout the mould's life.

Storage of dry plasters

Plaster should be stored in a dry atmosphere at a temperature not less than 13°C and in an airtight container. Preferably, it should be in its bag in a plastic dustbin with a well-fitting lid. Some manufacturers produce bags lined with plastic to help with this.

Plaster has a shelf-life of no longer than three months. Older plaster has probably absorbed moisture from the atmosphere which will ultimately affect the mix thus increasing the risk of lumps and unevenness, as well as prolonging the setting time and reducing the strength of the set plaster. Most manufacturers date-stamp their bags and plaster should not be stockpiled but rotated so that the oldest plaster is used first. It is best to order only a few bags as necessary,

Plaster – water ratios

As previously mentioned, the predictability of a mix is one of the key points to successful mouldmaking and so a tried and tested method of weighing plaster and measuring water is essential to ensure a consistent mix of plaster each time. It is possible, and often practised, to mix plaster without measuring, using the method of filling a bucket half full of water and adding plaster until it barely breaks the surface of the water. However, there is room for error with this method and so, unless experienced, it is advisable to adopt the habit of

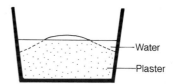

'Bucket method' for measuring plaster.

Plaster/Water Ratio Chart

Plaster/ Water Ratio by weight (Plaster = 100)	Weight of Plaster per pint of water lb oz		Weight of Plaster per litre of water kg
100/80	1	9	1.25
100/74	1	11	1.35
100/69	1	13	1.45
100/65	1	15	1.54
100/59	2	2	1.70
100/54	2	5	1.85
100/50	2	8	2.00
100/45	2	12	2.22
100/42	3	0	2.38
100/40	3	2	2.50
100/35	3	9	2.86
100/33	3	13	3.03
100/30	4	3	3.33
100/28	4	7	3.57

Plaster/water ratio chart. *Courtesy of British Gypsum.*

measuring using a set plaster – water ratio. A general guide is 1 pint of water to $1\frac{1}{2}$ lb of plaster which can be expressed as 2 parts of water to 3 parts of plaster or a 2:3 ratio. However, when talking about consistency, the equation is normally based on 100 therefore 2 : 3 becomes 67 : 100, i.e. 67 parts water to 100 parts of plaster. The following ratios are suggested for making slipcast ware by British Gypsum. Adjustments will, however, need to be made according to the particular clay body used and the individual application.

To obtain an understanding of different consistencies of plaster, a couple of tests can be carried out. For example: (a) by altering the plaster – water ratio. Add more or less plaster to a given amount of water:

Plaster	Water
$1\frac{1}{4}$ lb	1 pt = softer/weaker mix
$1\frac{1}{2}$ lb	1 pt = standard mix
$1\frac{3}{4}$ lb	1 pt = harder/denser mix

Or, (b) when using less water in relation to the plaster weight, the mix will become naturally less fluid and therefore the setting time and period of plasticity are shorter. This makes a dense, harder mix and is useful for modelmaking where absorbency is not the key factor. It can also be useful for some mouldmaking techniques where moulds are used in conjunction with machines, tooling and plastic clay, i.e. jigger and jolley machines where the strength of the mould is important. Conversely, the more water used in relation to the plaster weight, the opposite will happen resulting in a softer, weaker mix.

The ideal ratio for moulds used in slipcasting is one which provides an even absorption and a mix which is neither too soft nor too hard, for example:

Application	Pottery Plaster	Keramicast
CAST MOULDS		
China	100/80 1.25kg/litre 1lb 9oz/pint	–
Earthenware	100/76 1.35kg/litre 1lb 11oz/pint	–
Stoneware	100/74 1.35kg/litre 1lb 11oz/pint	–
JOLLIED MOULDS		
China	100/77 1.30kg/litre 1lb 10oz/pint	100/71 1.41kg/litre 1lb 12oz/pint
Earthenware	100/74 1.35kg/litre 1lb 11oz/pint	100/71 1.41kg/litre 1lb 12oz/pint
Stoneware	100/74 1.35kg/litre 1lb 11oz/pint	100/69 1.45kg/litre 1lb 13oz/pint
HAND PRESSED MOULDS		
All types	100/71 1.41kg/litre 1lb 12oz/pint	100/63 1.59kg/litre 2lb 0oz/pint

Application chart. *Courtesy of British Gypsum.*

Plaster	Water
$1\frac{1}{2}$ lb	1 pt

Blending and pouring

Permeability, porosity, hardness, strength and durability of the mould, workability and surface characteristics, are all related to the blending and pouring procedure. Once the ratio has been decided, then the following key points need to be respected to ensure a consistent mix or blend of plaster each time.

1. All implements must be clean of old plaster as dry plaster left in buckets accelerates the setting time of fresh plaster.
2. An important point to remember is that plaster is added to water and not the other way around.

3. Water should be at room temperature.
4. The weighed plaster should be gradually sifted with your hand into the water to avoid air being trapped. This also allows as many particles as possible to be saturated before the soaking, or slaking, takes place.
5. Let the plaster soak for at least 1–2 minutes. This ensures complete saturation and dispersion before the blending starts. It also allows for any air bubbles to rise to the surface, and the occasional tap with the foot on the side of the bucket aids this action.
6. To mix by hand, place outspread hand into the bottom of the bucket and start stirring in one direction only, keeping the hand below the surface of the water. This reduces the amount of air which could be trapped. Keep stirring with a regular rhythm – the slower the stirring, the longer the mix will take to 'go off' or set, – the faster the stirring, the quicker the mix will set. Any air bubbles which gather on the surface can be skimmed off. A rough guide for mixing, i.e. the time from adding the plaster to the time of pouring is approximately 10–15 minutes. However, certain factors will affect this, e.g. type of plaster used (refer to manufacturers' recommendations), temperature of water, i.e. warmer = faster setting/ cooler = slower setting, plaster – water ratio, and the total quantity being used. For smaller quantities, up to $1\frac{1}{2}$ lb of plaster, the mixing can be done with an egg whisk or spoon. For larger quantities, mechanical mixers can be used and this tends to speed up the mixing process.
7. The consistency of the mix will gradually change from a thin liquid, barely covering the fingers, to a creamy texture (with virtually all the air bubbles dispersed) which will coat the fingers. (A guide for testing whether the mix is ready for pouring is if the plaster leaves a slight visible trail on the surface.)

It is advisable to approach your model a few moments before you feel you are ready to pour as the plaster, once ready, turns very quickly and can become too set if time is lost preparing to pour.
8. Before pouring, make sure you are at a comfortable height above the model or mould. Do not pour from too a high a distance as air may be trapped. Then, pour steadily in an even, continuous stream, preferably in one spot near the inside of your cottle.

– too slow a pour will result in the plaster starting to set in the bottom of the bucket before reaching its destination. Also, setting in folds will form large air gaps.
– too quick a pour will result in 'glugging' and splashing and thus inevitably trapping air.

Tap the sides of your cottle and gently shake the poured plaster to encourage any air bubbles to rise to the surface.
9. Any large excess amounts of plaster which still remain after pouring can be placed onto a sheet of glass with another sheet of glass placed on top. Use three spacers $\frac{1}{2}$ inch (12 mm) thick made from wood or plaster and place on the first sheet. These will serve as levellers and so a completely true 'bat of plaster' can be made.

Small surplus amounts of mixed

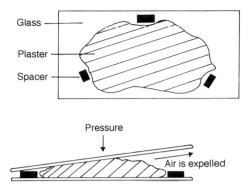

Glass

Plaster

Spacer

Pressure

Air is expelled

Making a plaster bat between two sheets of glass.

plaster should be put into a waste bin, not down the sink, and the buckets and any tools used should be cleaned thoroughly ready for the next mix. There is a school of thought which suggests leaving the excess plaster to set in the bucket and then cracking out. The disadvantages of this method are that some buckets if not very solid, will split themselves, and also, when working with other people, there will always be a back log of dirty buckets. If possible, the clean buckets should be left to soak in a container or large sink full of clean water. This will ensure that there

are no dry bits of plaster left which could affect a new mix of plaster.

10. The cottle can be removed and the lump is then ready to be modelled, i.e. turned, carved etc. or scraped and tidied up if it is a mould. To determine whether the plaster has set, use the 'nail test' i.e. when a fingernail leaves an impression on the surface.

Drying and storage of moulds

Moulds must be dried before using. It is advisable to dry them slowly in an airing cupboard or in a drying cupboard, provided the temperature does not exceed 40°C/104°F. Force drying on top of the kiln is not recommended as it is a very uneven way of drying and the bases of the moulds can become scorched and break up. (Note: If plaster, once set, is reheated too violently it will break up and start to crumble.) When removing the moulds from a drier, take care to avoid any thermal shock which could occur due to differences in temperature. The odd 'ping' you can hear will mean there is a crack somewhere in the mould. Moulds should be stored in a dry place at temperatures around 16°C/61°F.

Chapter Two
Tools and Materials

Work area requirements

If at all possible, the plaster and slipcasting areas should be separate. Ideally they should be in two different rooms but, realistically, as space is usually at a premium in a workshop, the room can be divided up into two different areas. This is necessary because contamination of slip or clay with plaster can have disastrous results. Plaster, when inadvertently trapped in slip, or in a clay wall, expands when it absorbs water from the surrounding clay and so, once the cast or piece is fired, the trapped piece of plaster can form a crater or, more dramatically, explode through the wall of the piece.

Plaster area

Work benches should ideally be made of a smooth non-porous material such as formica or melamine mounted onto a table top or work surface. Originally, marble was used as the traditional work surface, however, as it is difficult to find large slabs of marble, old wash stands which have marble tops can be used and set into a table top. If the marble is polished to an almost glass-like finish, plaster can be poured directly onto it without sticking. A slightly rough or coarse marble, however, will encourage the plaster to stick. Nevertheless, this can be very useful in grinding down models or excesses of plaster. An old kiln bat can be used as an alternative.

Sink

One with a plaster trap or ideally two large plastic moulded tanks which are deep enough for submerging buckets are a valuable addition to any workshop. One is for 'clean' water – for soaking buckets and dry plaster models or bats in preparation for moulding. The other is for 'dirty' water, i.e. cleaning buckets and tools etc.

For cleaning the tank which has collected plaster in the bottom use the following procedure:

1. Allow the plaster to settle to the bottom where a residue will form.
2. Drain the clear water off by removing the pipe.
3. Scoop out the residue and place the wet plaster into old plaster bags and dispose of it.

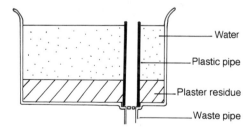

Sink with pipe for plaster 'trap'.

Equipment and tools

Machinery

Large expensive items of machinery are not essential but should they become available are well worth considering:

Plaster turning lathe (horizontal turning)

Not a necessary item but very useful for creating round, symmetrical forms. Plaster lathes which have been custom-made are expensive; however, second-hand converted wood or metal turning lathes can be a very good solution.

Bench whirler (vertical turning)

Again a useful item to have for making flatware i.e. saucers, plates etc., and for mouldmaking. The whirler offers the possibility of turning the excess off the exterior of the moulds thus obtaining smooth, even surfaces. It also allows for the introduction of a recess to be turned into the base which allows for standing completely flat.

Whirler with spindle and 'spacers'. *Courtesy of Ecole Nationale d'Art Decoratif, Limoges, France.*

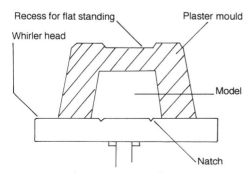

Bench whirler with mould.

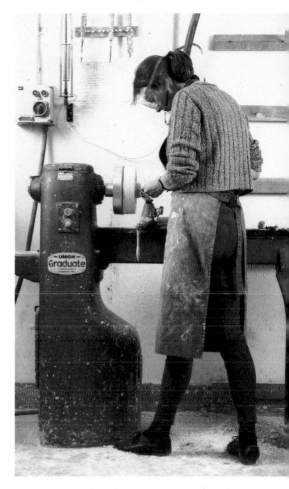

Floor-standing plaster turning lathe. *Photograph by Steve Hook.*

Bandsaw

Useful for cutting flat forms out of plaster bats, particularly when making handles or moulding bats.

Blunger

A small blunger (approximately 15 gallon (68 litres) capacity) is necessary if you are planning to mix up your own casting slips from powdered or plastic clay. For smaller batches, a rapid glaze mixer will suffice (approximately 5 gallon (23 litres) capacity).

Blunger (25 gallon capacity). *Photograph by Steve Hook.*

Plaster mixing equipment

Large plastic dustbin with lid and scoop

For storing plaster in an airtight container to avoid humidity from the atmosphere being absorbed. An old flour scoop for weighing out the plaster.

Jugs

Choose either a 1 pint or 1 litre plastic jug as it facilitates counting when measuring the water.

Weighing scales

Large enough to hold up to 14 lb or 7 kilos.

Buckets and basins

Assorted sizes of plastic or rubber buckets and basins (available from Tiranti, see suppliers). Being flexible they are ideal for mixing and cleaning out. A bucket with a lip aids pouring.

Spoons and whisks

Useful for blending small amounts of plaster in small containers.

Cottling material (retaining walls for round and irregular forms)

Flexible plastic sheeting

Transparent high density plastic sheeting ($\frac{1}{8}$ inch (3 mm) thick) which is available in various lengths and widths (no soaping required).

Linoleum

Very suitable and a cheaper alternative to plastic sheeting. However, if possible use a non-textured surface (no soaping required).

Soft clay

Used for small moulding walls, i.e. knobs etc., rolled out slabs cut to size (no soaping required).

Roofing lead

Used for small moulding walls. Flexibility

follows any form of bed and is re-usable. Flatten out with a rolling pin and then shape around bed of model or mould (no soaping required).

Cottling material (retaining walls for square or rectangular forms)

Wooden board

Use marine ply, if possible, as it is more resistant to water. Cut to fit object using thicknesses of $\frac{1}{2}$ inch (12 mm) to $\frac{3}{4}$ inch (16 mm). For easy releasing, soap up before use (see Chapter 3). Alternatively, melamine strips are ideal as no soaping is required.

Plaster bats

These serve as very useful retaining walls as they can be easily cut to size by hand (by scoring halfway through with a knife and breaking the bat in half) or by using a band saw. Any excess of plaster can be made into a bat and stored (see Chapter 1). Soaping up is essential to avoid sticking to freshly poured plaster. They can be re-used provided careful removal is ensured.

Soft clay

Rolled out slabs cut to size are useful for small objects, i.e. handles etc.

Materials for securing cottles and retaining walls

Clothes pegs

For holding cottles together prior to securing with string.

String

Varying lengths of strong string, preferably plaited nylon string with a knot at either end. This facilitates the fastening and unfastening of the cottle without having to bother with elaborate ties. The knot is slipped underneath the already tightly wound string.

Soft clay

For claying up seams on the outside of cottles and retaining walls.

Materials for soaping up (see Chapter 3)

Soft bristle brushes

Soft bristle brushes – For applying soft soap.

Natural sponges

Natural sponges – Dampened for removal of excess soap.

Dry soft bristle brush

Dry soft bristle brush – For buffing up at the end of soaping up process. An ideal brush for this is a flat Japanese hake brush or glaze mop.

Soft soap or mouldmaker's size

An industrial soft soap available from a pottery supplier is the best. This normally comes in a solidified form and requires diluting with boiling water until it dissolves. An estimated measurement is 50% soap to 50% water. Alternatively, a commercial liquid soap is adequate.

Basic tools

Tools are a very individual matter and experience will identify the best ones for your particular way of working. However, I have attempted here to list some essential items and their uses.

For use with wet plaster

Plaster turning tools
For use on a lathe or a whirler. These can be made from wood-turning chisels and by grinding the tools to a small selection of different shapes as illustrated below:

Cross-section of turning tools or chisels.

They need to be regularly sharpened as plaster is very abrasive. Whirler turning tools can be adapted from clay turning tools.

Scrapers or metal kidneys
These are particularly useful for finishing a turned model or for smoothing over or screeding (setting plaster when mouldmaking). An assortment ranging from rigid to flexible ones is advisable.

Sheet metal
Sheets of galvanised metal or zinc plates are very useful for template forming used in conjunction with sledging and profiling techniques (see Chapter 3).

For use with hardened damp plaster

Carpenter's saw
Used for cutting off large areas of plaster.

Surforms
Four types of surform blades, i.e. straight (long), straight (short), curved and round; used for carving.

Rifflers or forged steel tools
These have serrated edges and, although expensive, the cost can be cut by buying a couple of the dual purpose rifflers as they are available with a blade at either end with two different cutting surfaces, i.e. four different blades on one tool. These are extremely useful for detailed carving work.

Hacksaw blades
A variety ranging from coarse textured blades to very fine ones without the handle are indispensable tools when modelling.

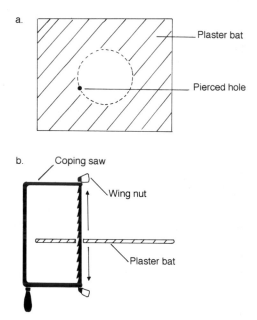

Coping saw cutting through plaster bat.

Start by drilling or piercing a hole in the plaster with a pointed tool. Undo the coping saw blade and thread it through the hole. Tighten up the blade on the other side with the wing nut and saw vertically moving gradually around the hole taking care not to bend the blade.

Coping saw
With the option of a 45° angled blade. Ideal for cutting out negative circles from a plaster bat.

Variety of rasps, files, knives and gouges
NB. All metal tools must be cleaned after use and dried to avoid rusting. Wash and scrub in water.

Miscellaneous tools

Indelible pencils
Indispensable tool for use when mouldmaking as centre- and guidelines can be marked on the form. These aid carving and modelling and can only be removed by carving off in the short term, though they wear off in the long term.

'UHU' glue
For gluing pieces of plaster together prior to moulding. In particular, 'spares' to the top of moulds when forming the reservoir rings (see Chapter 4). The heat and the moisture from the expanding plaster during moulding releases the glue.

Wet and dry paper
Various grades of carborundum paper ranging from 240 to 1000 grade are useful for finishing the plaster surfaces of the models and for tidying up sharp edges on the moulds. Occasionally used in fettling edges on casts.

Callipers
Vital for measuring dimensions accurately, particularly when turning and where lid fittings are necessary.

Flexicurve
Flexible rubber ruler used in conjunction with indelible pencils when tracing the curved profile of an object.

Compasses
When used in conjunction with indelible pencils, they are necessary for dividing a model up to find the centre line (see Chapter 4).

Coins
Used for making 'natches' when mouldmaking. Use an assortment of 1, 5, and 10 pence pieces.

Straight edges
Metal rulers, old saw blades with the teeth ground off etc. are useful for screeding flat areas of plaster.

Steel square
For determining a perpendicular surface.

Small spirit level
For finding 'true' surfaces prior to moulding.

Rubber mallet
For releasing models from moulds by tapping on the base of the mould.

Steel hammer
For use in conjunction with straight edges for splitting off moulds (see Chapter 5).

Inner tubes
For securing moulds when casting. Cut bands to a variety of widths. For larger moulds, join 2 to 3 bands together. Alternatively, use a self-tightening belt with wooden wedges as large moulds can come apart with the pressure of a large quantity of slip being poured in.

Dottle sponges
For softening edges and rims after casting (sponging back).

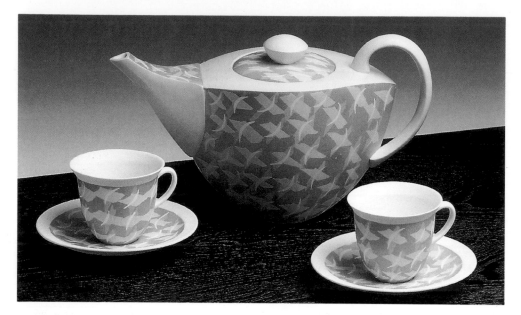

Paintbrushes
Small assorted brushes for painting slip on to the piece when assembling handles, spouts and feet etc.

Coarse felt
For buffing up plaster surfaces after turning or carving. Sometimes used for dry fettling on casts.

Semi-porcelain teapot and bone china cups by Sasha Wardell, 1988, h. 20 cm teapot. *Photograph Mark Lawrence.*

Sieves
60s mesh for preparing slip
120s mesh for screening glaze
200s mesh for screening colour and glaze

Banding wheel
For use in model and mould making.

Chapter Three
Modelmaking

Materials used

A variety of materials including plaster, wood, glass, perspex, clay, plasticine or Styrofoam can be used to make the original form or model prior to moulding.

The decision on which material to use is determined by the desired finished quality and overall appearance of the piece. For example, for precise, angled forms – hard materials such as plaster, wood or perspex are the most suitable. On the other hand, soft sculpted forms such as animals or figures would require pliable materials such as clay or plasticine. Plasticine is also useful for fine detailed work such as surface modelling and decoration where clay would present a shrinkage problem.

In some cases a combination of soft and hard materials are the best solution, i.e. a plaster original with a plasticine modelled relief pattern on top.

Preparation of chosen materials prior to moulding

Clay or plasticine

If your model is to be made from these materials then straightforward modelling techniques are applicable. It is advisable to make your piece solid as the weight of

Triangular vases by Sasha Wardell, h. 15 cm, 1979. The models are made from primed wood and cast in semi-porcelain. *Photograph by John Law.*

the plaster, once poured over the model, can buckle or deform it. It is best to make the mould when the clay has become leatherhard, because if it is any drier, it will be necessary to use some form of soaping (described in detail on pages 28 and 29) to prevent the plaster from sticking, as dry clay becomes slightly porous.

Wood

This tends to be an absorbent material and so treatment of the surface is normally necessary. This is done for two reasons. Firstly, unless the texture of the wood is an integral part of the design, a smooth surface is necessary. This can be done by painting or spraying two to three coats of wood primer onto the model, sanding down in between each coat. Secondly, the primer gives a non-absorbent surface and so soaping is not necessary. If using un-primed wood, then soaping is necessary.

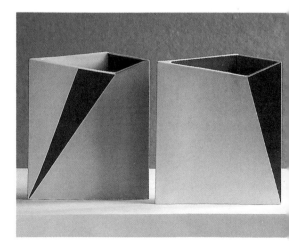

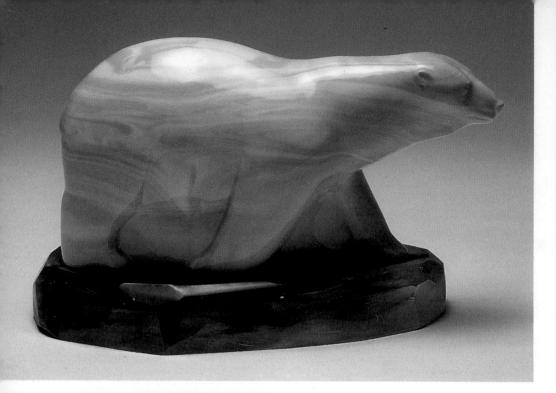

Polar bear by Alma Boyes. The model is sculpted in clay from which a 4-piece mould is made. It is cast in bone china and requires no setting (see Chapter 7) as the form is strong in itself. To obtain the agate effect, two coloured slips are poured in to the mould at the same time. Fired to approximately 1240°C and treated with a low-solubility glaze which enhances the colours and finally fired to 1080°C.

Left
Felicity Aylieff surforming a styrofoam model.

Perspex

This material can be used for very precise or flat-sided forms. It can be cut and filed and glued using chloroform which melts the edges to be joined and so fuses the edges together, leaving no glue residue. It is a totally non-absorbent material and therefore no soaping is required.

Styrofoam

This is a hard foam normally used as an insulating material. It is available in large sheets. It is suitable for large-scale work in particular and can be cut to shape using knives, surforms and rifflers. A hot wire will cut through the material but care must be taken as toxic fumes are released when the material is heated.

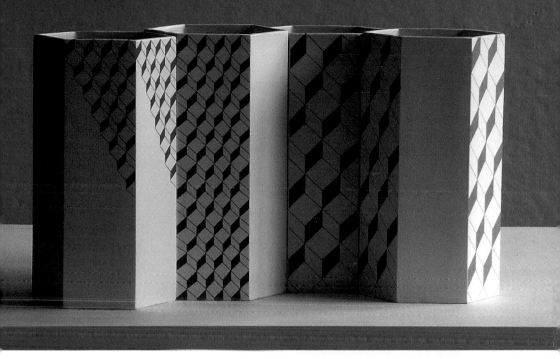

Hexagonal vases by Sasha Wardell, h. 18 cm, 1979. The models are made from perspex and cast in semi porcelain. *Photograph by John Law.*

Right
Pair of vases by Sasha Wardell, h. 10 cm and 18 cm, 1982. The models are made from turned and hand-carved plaster and cast in bone china.

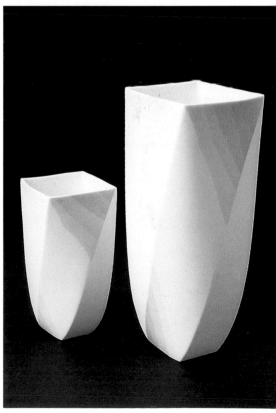

Prior to moulding, the object needs to be sealed with an emulsion paint, not a spirit-based one as this will melt the material.

Plaster

This is the material most favoured by ceramicists and industry for it has many advantages. In addition to the properties already mentioned in Chapter 1, it can be worked in either a wet, damp or dry state and although thin sheets of flat plaster can warp, it does not change its shape on drying. A good polished surface

can be obtained and once in a model form, it deteriorates very little with time if it does not come into contact with casting slips and their abrasive deflocculants (described fully in Chapter 6). Being a porous material, however, soaping is necessary.

Whether plaster is worked by hand or machine methods, a large variety of forms are possible.

Contraction of slips

Due to the fact that all ceramic bodies contract to a certain extent during drying and firing, the first consideration when modelling is to establish in which body the piece is to be eventually cast. Other than testing a sample yourself, contact the manufacturers for their guidelines concerning the shrinkage of a particular clay, bearing in mind factors which will affect contraction, i.e. slip condition and firing temperatures (maturing points). The model should then be made larger taking into account the approximate shrinkage rate.

GENERAL SHRINKAGE GUIDES FOR
SLIPS ARE:

Earthenware	– 10%
Stoneware	– 11%–12%
Porcelain	– 12%
Bone China	– 14%–15%

Knowing the contraction of a particular slip comes becomes important when calculating capacities of a particular object. In some cases it is necessary to make an object with an already determined capacity – for example, a teapot which will hold 40 fluid oz. One method of establishing this is to use the 'shrink' calculators, such as those invented by Donald Frith in his book, *Mold Making for Ceramics*.

Soft soap procedure

Soft soap is available from most pottery suppliers and is known as 'potter's size'. It normally requires diluting with boiling water using 50% soap and 50% water.

New plaster will stick to old plaster unless a seal or barrier is created on the surface making it non-porous. A soaping ritual therefore needs to be strictly adhered to. This is essential whether it be during a modelling method, when forms can be obtained by casting fresh plaster onto already cast plaster, or in the preparation of the plaster prior to moulding.

There are a number of variations on the soaping method which generally follow the same principle. However, the one I find the most successful is as follows. You will need: soft soap, a soft bristle brush, a natural sponge and a bowl of clean water and a wide soft bristle brush.

Method
1. Ensure that your model is damp. If it is dry, soaking in clean water for approximately 15 minutes or so, or until the air bubbles have ceased to rise, normally saturates the model enough. Do not over soak, however, as the plaster will start to deteriorate.
2. With a soft bristle brush (approximately 1 inch (2.5 cm) thick) soap the entire model thoroughly.
3. With a natural sponge that has been soaked in water and squeezed out, wipe the entire model thoroughly thus removing any traces of soap.
4. Repeat this process three times in all. Take care not to touch the model as grease from the fingers can prevent the soap from taking in places.
5. Finally, working under a good light,

with a dry brush (a wide soft bristle brush) buff up the surface making sure all the soap bubbles have been removed. Any soap left on the surface will react with the new plaster and cause a bubbling effect on the mould.

Be particularly careful with detailed areas and relief, not to trap traces of soap. A fine paintbrush is useful for removing any excess of soap.

What, in fact, is happening during the soaping process is that each time soap is applied to the surface of the plaster, a small amount is absorbed into the pores of the plaster. By wiping the excess off with a wet sponge and by repeating the process, a protective seal is gradually built up.

Industry refers to this soaping process as 'facing up' and 'sizing up'. Facing up is the method described above for sealing new plaster i.e. three times, and sizing up is soaping once in between moulds, i.e. plaster which has already been soaped and a plaster cast made for example when making production moulds during blocking and casing (see Chapter 5).

Plaster techniques incorporating hand and machine methods

The first part of this section deals with techniques based on the hand methods of working plaster.

The method described below can be adapted for any irregular form – the starting point being a preformed bat of plaster or tile.

Making a model for a tile

Make a plaster bat using the method described in Chapter 1. The thickness

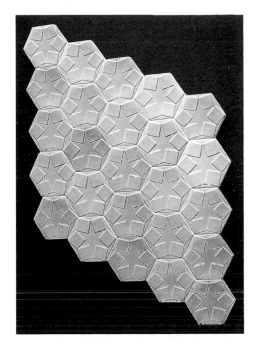

Hexagonal tile panel by Sasha Wardell, 1 m by 1 m, 1979. The models are made from a hand-carved flat plaster bat. *Photograph John Law.*

required needs to be approximately $\frac{3}{8}$ inch (1 cm). This will allow for double-casting in the mould (described in Chapter 5) which results in a solid tile.

Mark on the bat the desired form with an indelible pencil and saw the corners off or, score with a knife halfway through the bat and break cleanly with a sharp tap leaving a margin of approximately $\frac{3}{8}$ inch (1 cm) to allow for uneven breaking or sawing.

Place on a flat surface and start carving to the pencil marks using a succession of cutting tools:

a. Firstly, a surform (straight blade) cutting in one direction to rough out the shape.
b. Then a hacksaw blade, when nearer the line, using a cross-hatch movement.

Plaster tile model — Sand paper

Workbench — Block of wood

Tile model being sanded down.

c. A flexible metal kidney will smooth the surface from the previous tools.
d. Finally, wet and dry paper, used wet, will polish up the surface. To ensure straight sides wrap a piece around a small block of wood and sand the edges true keeping the model flat on the workbench.

Cottling around a preformed bat of plaster

For example, to make an oval form using a preformed plaster bat approximately 1 inch (2.5 cm) thick cut in the shape of an oval, use the 'tile' method described above.

Drawing an oval

a. Place two drawing pins (thumb tacks) onto the bat in a straight line approximately $2\frac{3}{8}$ inches (6 cm) apart.
b. Tie a loop slightly larger than the distance between the drawing pins. The larger the loop, the bigger the oval.
c. Place an indelible pencil into the loop keeping it as upright as possible at the same time maintaining the tension on the string. Trace around the pins making sure the string stays taut until the oval is traced. Once the oval has been traced, carve it out using the method previously explained.

Then set it up on the workbench and soap up thoroughly. Cut a sheet of cottling plastic a little higher than 4 inches (10 cm) – this will provide enough area to attach the larger cottling

Drawing an oval using string, drawing pins and an indelible pencil. *Photograph by Steve Hook.*

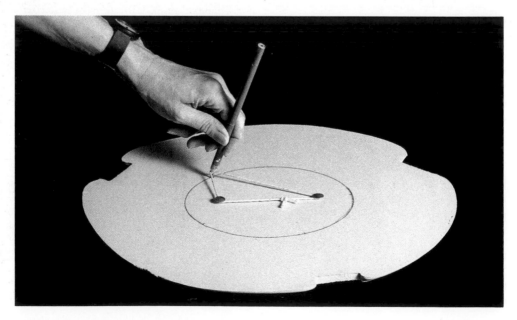

Oval model set up on a plaster bed and bat.

sheet around. Mix up the plaster and pour it into the cottle. Once the plaster has set enough to remove the cottle (using the nail test), scrape down the join line with a metal kidney. This will give a second oval bed deep enough to hold a larger/higher cottle around depending on the required height of the final oval. Soap up and repeat the plaster pouring.

Variations of model forming from carved elements

Interlocking forms

From an already turned or carved form, soap up an area and run fresh plaster over, or on to it. The new lump is then carved. However, the area where the fresh plaster touches the original is a complete 'fit' and will release, and will subsequently be moulded separately.

Assembling or sticking plaster

Join already formed plaster shapes which have been made separately by using plaster or glue, preferably 'UHU', as this will release after moulding.

Heron jug by Anthony Theakston, h. 40 cm. The plaster models for the handles and the feet are 'run on' to the body model prior to moulding.

Horizontal sledging

The technique of sledging has been adapted from the method that was used to make the interior plasterwork mouldings commonly found in architecture from the highly elaborate church and palace interiors of the early modern Europe to the urban terraced house of the 18th and 19th centuries. There are now only a few firms in this country who maintain the traditional skills of ornamental plasterwork, and they are usually located in urban centres with a high proportion of Georgian and early Victorian housing, e.g. Bath, Bristol, London and Leeds. The technique is useful for the purposes of model making for slipcast and pressmoulded ceramic pieces because it is a relatively quick process once the basic skills have been acquired. It is also a low technology method for which the maker only needs a few tools and offcuts of wood and metal. The most expensive item is the plaster itself.

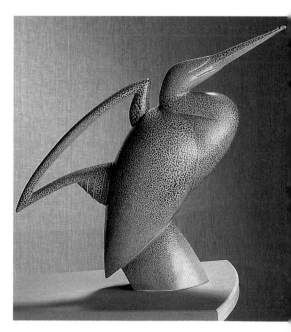

Sledge

A sledge should be made of blockboard or thick plywood, depending on the size of the section you intend to run. (If affordable marine ply is the best, for a longer life). A small section for a mirror frame, for example, could be run in a lighter wooden sledge. (Do not use chip board.) The sledge should be sealed with a good quality varnish. The sledge must be twice as long as it is broad to maintain stability while running, and it should be firmly braced across the top.

Tools required are: a saw, a drill and drill bits, a screwdriver and screws (do not use nails), and glue which can help to increase the strength.

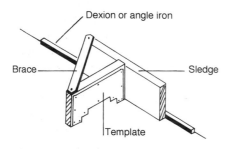

Horizontal sledge.

Template

The metal template should be made of $\frac{5}{8}$ inch (16 mm) galvanised steel. However, offcuts from old zinc etching plates will do – anything which does not rust too rapidly. The profile should be traced onto the metal using a paper pattern. Care must be taken to ensure it will fit the sledge – especially if two profiles are to be used. It is very important to take care in cutting and filing the profile as a good finish will mean less work to be done on the finished plaster section. The template must be filed to a 45° angle. The sharp

edge will be driven into the plaster, so it is important that the template is fixed to the sledge the right way round, i.e. in the direction you intend to run the sledge.

Tools required are: a hacksaw, coarse files and needle files for finishing, emery paper, a drill and drill bits, a screwdriver and screws.

Running the sledge

Find a length of angle iron or strong dexion long enough for the amount you require to make the model. Clamp it to a flat surface and apply engine grease or Vaseline to the metal surface against which the sledge will run, and to the flat surface over which the sledge will make contact. Do not apply too much grease or the sledge will skid. When running the sledge through the plaster, it is important to keep it in continuous contact with the guide, otherwise it will twist and prevent smooth running as the plaster hardens.

Preparing to run the plaster

It is most important to be well prepared as there is not much time to lose when the plaster starts to 'go off'. A water supply must be close at hand. Buckets must be prepared to hold the plaster mixes. Line them with Vaseline or bin bags if you want them to last longer. A sponge is needed to clean the template between runs, and it is a good idea to have a paint scraper to hand in order to clear the 'runway' of unwanted plaster.

Plaster

It is possible to retard the setting of the plaster but it is very difficult to achieve a good surface finish on the model if you

do this. It is really worthwhile to obtain an 'alpha' high expansion plaster from a supplier. It has a slower setting or curing period than most plasters, and the expansion allows a finer surface to be achieved. It is also most important that the plaster be fresh. If it is not, or if it has become damp in storage, it will be difficult to achieve a smooth mix and it will set more rapidly.

There should be two mixes prepared, one large mix to ensure there is sufficient to form the model, and one small mix to be applied as the plaster starts to harden in order to improve the surface quality. When the first mix is of a consistency thick enough to stay in place, it can be poured onto the 'runway', taking care that it reaches to a sufficient height and width to be taken up by the template.

It can be helpful to use lengths of wood to act as a 'trough' to contain the plaster before running the sledge through it. The sledge should be passed through the plaster repeatedly, but after each run the template must be cleaned of excess plaster.

When the plaster starts to hold its shape and harden, apply the second mix over the entire surface and run it immediately. Cold water sluiced over the surface can also improve the finish and remove any grit likely to scratch the surface. It is most important to stop running the sledge before it starts to jam or judder over the plaster as it hardens. However, this can only be judged as the result of experience.

Amounts of plaster have to be gauged by trial and error and this also becomes much more accurate with experience. Ideally, the plaster should be weighed to the pint weight recommended by the supplier as this does enable relatively trouble-free sledging because the plaster will be more likely to behave at its best.

Ensure that the recommended curing time has passed before attempting to remove the model and work on it further. It is a good idea to have two people to run a model when inexperienced or when running on a large section as timing is most important to achieve a good finish.

Points to bear in mind – it can be difficult to develop three-dimensional forms using this technique which do not resemble offcuts from a Georgian ceiling moulding. It is a very appropriate technique for a framing device, but with more imaginative application it can be used to develop forms with a distinct difference to those arrived at by other methods. The use of two templates to make a negative into which a positive form is sledged, can liberate the technique from the ceiling moulding reference. Further modification through carving or the addition of other sections is also possible.

It is suitable for models which may become vase forms or boxes – and it is possible to cut the template to make allowances for the distortion in the clay form, therefore incorporating a generous curve to avoid the tendency of cast clays to 'suck in' on a flat surface. There are numerous, but more complex applications, for example, sledging an oval frame, a wave form, diminishing forms which involve the use of a hinged sledge between two guides thus creating a fan shape, two way sledging for pyramids, box forms and relief tiles which require a modified box sledge.

Profiling or vertical sledging

This technique follows the same principle as the method described above except it is used vertically to produce

models for which the profile is constant but the section is anything other than round. This method combines preformed plaster bats and either a clay or plaster model which is scraped to form by a template or profile.

Making a plaster model

As an example: a hexagonal plaster bat is cut to shape and placed on a glass shelf. The profile of the form is cut from a zinc template. A cottle is placed around the plaster bat with a margin of approximately $\frac{7}{8}$ inch (2 cm) and the plaster poured in. As soon as the plaster

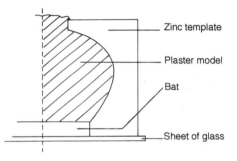

Profiling to make a plaster model.

begins to 'go off' or set, the cottle is removed and scraping or profiling can begin using the sheet of glass as a guide which keeps the template running smoothly. Wetting the plaster by squeezing a wet sponge periodically between scraping is necessary as this retards the setting time and creates a plaster slurry which eventually polishes the surface. When the form is finished and after it has hardened up, then the final polishing can be carried out. Timing is of the essence and sometimes a couple of attempts are necessary.

Making a clay model

The same procedure applies for the plaster bat as described above. However, the template is normally made from plaster instead of zinc, in this instance. Soft clay is built up into a rough form and the template is scraped against the clay until the form appears. As before, the sheet of glass acts as a guide to help keep the profile upright. With the clay model method there is more time. However, the surface will be rougher than that of a plaster one and so sanding work in the subsequent mould will be necessary.

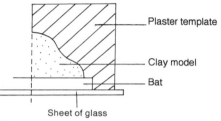

Profiling to make a clay model.

Machine-formed plaster models

Plaster lathe – horizontal turning

This method is ideal for turning a symmetrical form. Wood and metal turning lathes can be successfully adapted for turning plaster by using a metal chuck or spindle to receive the plaster lump prior to turning. Alternatively, there are lathes which are specifically designed for turning plaster. They have variable speeds and reverse control for polishing into which varying chucks and spindles can be attached.

In my experience, I find chucks are more convenient for turning smaller objects as there is no chance of the lump

dropping off or slipping. In addition to this, there is no hole running through the centre of the lump which can be a weak point when removing the model from the spindle. If a form has been turned using a spindle, however, then the hole running through the middle will require filling with plaster prior to moulding.

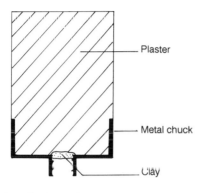

Chuck with plaster lump.

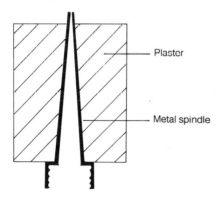

Spindle with plaster lump.

Preparation for turning using a chuck

If the model is to be of a specific size, make a technical drawing of the item and using stiff card, cut a template of exactly half your object. Remember to take into account the fired shrinkage size beforehand.

1. Sharpen the turning tools on a grinding wheel or stone.
2. Decide on the width of the model and use a chuck which corresponds. Make sure the chuck is as clean as possible and dampen it in water if any dry plaster remains.
3. Prepare the cottling sheet, taking into account the height of the model plus 1 inch (2.5 cm) extra for cutting off and sponge it clean. Have nylon string, pegs and soft clay ready.

Card template with profile and dimensions.

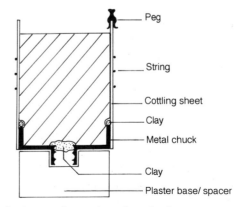

Setting-up the cottle with a chuck.

4. Place the chuck onto a 'spacer' or plaster base for support or secure with clay. Wrap the cottling sheet

35

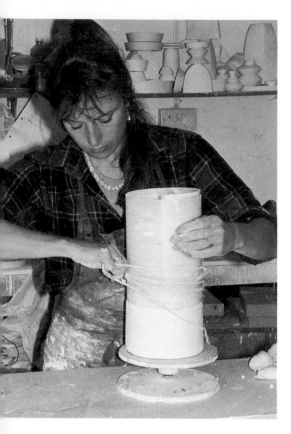

around the chuck tightly and secure with pegs where the sheet joins. Then using some nylon string which is knotted at each end, tie it tightly around the cottle. Seal the inside of the cottle with clay.

5. Mix up the required amount of plaster and pour slowly but evenly down the inside of the cottle, taking care not to trap air. When all the plaster is poured in, shake the cottle carefully and tap the plaster with the back of the hand to help the air bubbles rise to the surface.

6. Let the plaster harden slightly before removing the cottle and place the lump on the lathe. The lump is easier to centre and turn when still slightly soft.

Securing the plastic cottle with string. *Photograph by Ron Adams.*

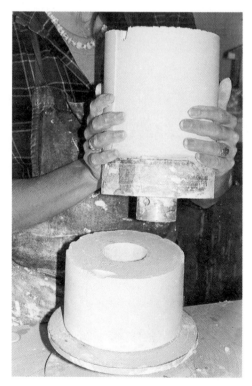

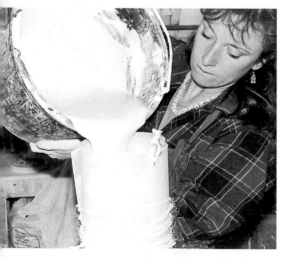

The plaster is poured steadily near the inside of the cottle. *Photograph by Ron Adams.*

The cottle is removed and the plaster is contained at the base by the chuck. *Photograph by Ron Adams.*

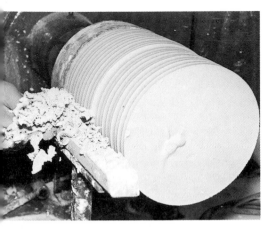

Centring the plaster on the lathe. *Photograph by Ron Adams.*

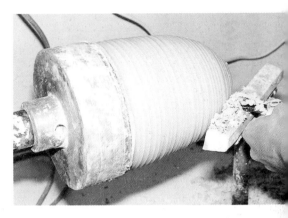

The model gradually takes shape using a variety of turning tools. *Photograph by Ron Adams.*

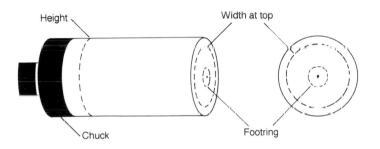

Smoothing down the surface of the model using a metal kidney. *Photograph by Ron Adams.*

Centred lump of plaster with indelible guidelines and measurements marked in preparation for turning the shape.

7. The first operation is to centre the lump using a fairly wide rounded turning tool. To help visualise the form before turning has started, use an indelible pencil and mark various reference points, i.e. the centre of the lump, the height, the width and the foot.

8. Gradually, the form is turned using a succession of different cutting tools as in the hand-carving method. Start with a wide rounded turning tool, then a finer rounded one until the shape is roughed out. To smooth down the surface, use a metal

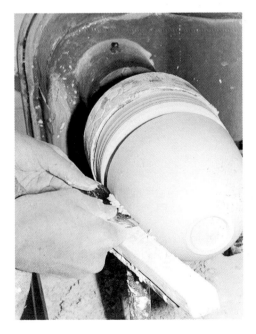

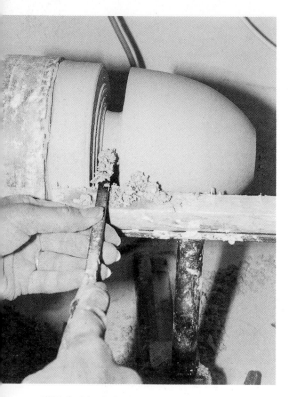

The finished shape is turned-off the lathe using a parting chisel. *Photograph by Ron Adams.*

Grinding down the top of the model on a slab of marble or ground glass.

kidney and finally some wet and dry paper for polishing.

9. The finished form is detached from the lathe either using a saw or turning off with a parting tool.

10. To make a completely flat surface after the form is cut off the lathe, place the model upside down on a slab of marble or ground glass and grind it until it is completely flat and smooth.

11. Clean the chuck by turning out the waste plaster until the bottom of the chuck is reached.

The same method applies for turning using a spindle, however, the spindle will need a sheet of wet newspaper wrapped around it to aid with the adhesion of the plaster to it. Due to the spindle being tapered, the plaster lump can work its way off if it is not secured properly.

Whirler or plaster wheel – vertical turning

An alternative to lathe turning is working on a whirler or plaster wheel, turning in a vertical position for hollow-ware and horizontally for flatware, i.e. plates, saucers, dishes etc. This technique requires more speed and co-ordination than lathe work as most of the shaping has to be carried out whilst the plaster is still very soft.

Preparation of the whirler head

1. The whirler head, which is made from plaster, is normally approximately 3 inches (7.5 cm) thick and can be up to 18 inches (45 cm) in diameter with a series of grooves turned into the surface. These are made using a triangular turning chisel. The grooves act as anchors for the new block of plaster which is cast on top. An extra layer should be used because running a model directly onto the plaster head can cause problems if the head is constantly turned and grooved inadvertently whilst making the model. It is much easier to replace a new block than it is a new whirler head.

2. Once the whirler head is prepared,

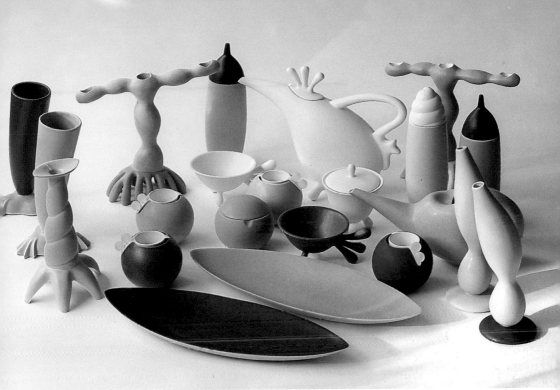

'1992/1993 Collection' by Ulrike Weiss (France). The models are either turned on a whirler or carved directly from a block of plaster.

Right
Preparing a whirler head.

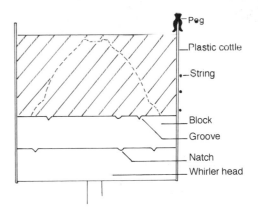

soft soap the plaster three times. This is important so that you avoid a very hard layer of plaster at the join between the two layers. It also facilitates removal of the top block when necessary.

3. Place a cottle around the head, using either an aluminium sheet or a stiff plastic cottling sheet. Secure it tightly using a band clamp or nylon string. If you are using an aluminium cottle, the inside should be treated with a separator such as a grease or WD40.

4. Mix up the required amount of plaster to make a block of approximately 3 inches (7.5 cm) deep and pour carefully into the cottle – preferably sliding the plaster down the inside surface of the cottle. This, as described in the lathe section, will minimise the danger of any air bubbles being trapped.

5. Start turning as soon as the cottle can be removed. It is important to gauge the optimum condition of the plaster – one way of doing this is to use the 'nail' test as previously described.

6. The initial turning is carried out using a triangular cutting tool supported by the hands in conjunction with the 'belly' stick. It is virtually impossible to explain verbally how to turn on a whirler as it is a combination of body movement and controlled hand positions working in rhythm with the revolving plaster. The bending of the knees is the source of the movement with the 'belly' stick acting as the pivot point. Only practice and coordination can perfect this technique.

 The block needs to be turned completely flat and should be checked with a spirit level.

7. In preparation for model making, turn either one or two grooves, depending on the size of the lump to be turned, plus a knatch into the level plaster block.

 Draw an indelible pencil line to indicate the extremity of your model. This line will remain during turning and will serve as a guide. Soft soap the plaster block as previously described and cottle up to the required diameter.

 It is now ready to accept the plaster for the model and turning can begin.

It is very important not to begin with a lump of plaster larger than you require. Roughing out the form quickly before the plaster has matured is essential when working on the whirler and having to turn off unnecessary excess loses time.

Modelling handles and spouts from plaster

The main problem when modelling handles and spouts is twisting and crookedness. The methods described in this section provide a way of minimising this risk.

Modelling a handle

There are two main methods of handle modelling, both of which may require several attempts at carving on a small scale. It is for this reason that two or three 'blocks' of plaster should be prepared to allow for breakages.

The first method requires pouring a plaster block, or lump, directly onto the model. The advantage of this method being that the 'fit' between the handle and the model are exact. The second method involves carving a handle directly from a cast plaster bat. Initially, this appears to be the quicker of the two methods, however, time is then spent on obtaining a good fit between the handle and the model.

Method 1

1. Using an indelible pencil, find the centre line of the model and mark the width of the handle, either side of the line, including the section or points where the handle joins the model.

2. Soap up the model and lay it on its side. Cut a plaster bat to fit the profile of the model and place it just below the width line supported by a bed of clay. True up with a spirit level to get the bat as flat as possible and remember to soap up the bat.

3. Mark on the plaster bat the required profile of the handle and place a clay wall around the marked area allowing for the width of the handle. Mix up a small amount of plaster and pour it into the walled area.

4. Remove the lump when the plaster has set. All the indelible pencil marks will have been picked up onto the

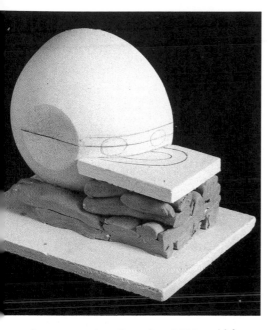

Setting-up a handle with indelible guidelines.
Photograph by Steve Hook.

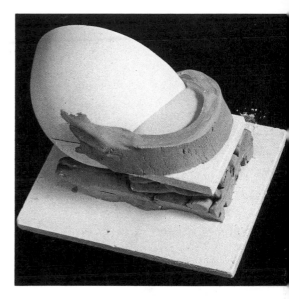

Plaster setting in clay wall. *Photograph by Steve Hook.*

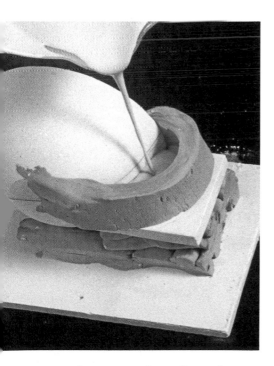

Pouring plaster into a clay wall to make 'handle block'. *Photograph by Steve Hook.*

Handle block before carving with 'picked-up' indelible guidelines. *Photograph by Steve Hook.*

lump and these will act as guidelines from which to start modelling. Smooth off the outside surface of the lump and mark as many guidelines as possible onto the plaster, in particular, continue the centre line and trace the profile of the handle from one side to the other.

Roughly carved-out handle. *Photograph by Steve Hook.*

In case of breakages during modelling, it is a good idea to prepare two or three blocks whilst the model is set up, remembering to soap up in between pours.

5. To begin shaping the handle, use a small surform knife to smooth out the rough areas. Then cut out the centre with a sharp scalpel or pottery knife. If the handle is large, excess plaster can be removed using a bandsaw or hacksaw. Be sure to get as close to your guidelines as possible. Do not touch any of the areas on the plaster lump which have been formed by the model or the profile bat.

6. Start modelling with a fine serrated edge tool, either a riffler or a small hacksaw blade working in a cross-hatch direction. Pare away at the surface gradually, carving both the inside and outside in turn. Look carefully at all the planes of the handle and present it to the model from time to time to ensure that proportions, trueness and design do not get lost. Most of the guidelines will eventually be carved away. However, do ensure that the central line is replaced until the fine detail stage is reached.

7. When the desired shape has been achieved, polish it with wet and dry paper, taking great care not to break it.

Method 2 (More suitable for forms with straight sides)

1. Prepare a plaster bat between two sheets of glass using three 'spacers' to achieve required thickness.

2. Draw onto the bat with an indelible pencil the desired shape and cut out the rough shape as described in Method 1.

3. Place a small piece of wet and dry paper onto the side of your model and hold firmly. Take the handle block and, before carving, hold it firmly against the wet and dry paper and the model, moving it from side to side. Gradually the fit of the handle will join snugly against the model.

Profile of handle and cup drawn on plaster bat.

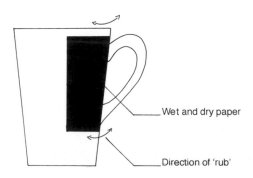

Handle being rubbed down to 'fit' side of cup.

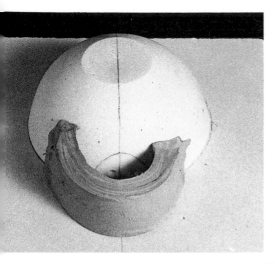

4. Mark the centre line onto the handle block and carve away, as before, using rifflers, hacksaw blades and wet and dry paper until the desired shape is reached. Make sure you check the handle periodically against the model.

Modelling a spout or 'snip' (jug lip)

In some instances, the block for the spout can be prepared at the same time as the handle once the model is set up and lying horizontally. Alternatively, the model can be in the upright position and the following method can be used:

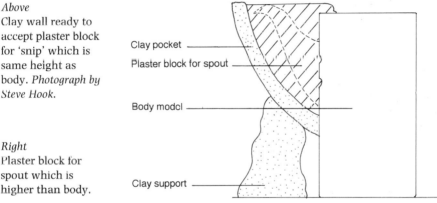

Clay pocket

Plaster block for spout

Body model

Clay support

1. Divide the model to find the centre line. Mark on the model the point where the spout or snip joins the model and include a horizontal line.
2. Make two small natches inside the join area and soap up the model. These registration marks will assist during modelling when frequent presentation of the spout is necessary as the natches will always locate the spout in its true position.
3. Add a clay pocket over this area sufficiently large and high enough to contain the proposed spout. It is sometimes necessary to add a clay support underneath if the mass of plaster is large.

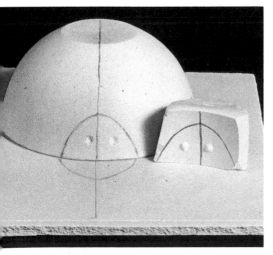

Snip and body after pouring, showing the location points and guidelines.

4. After the plaster has set, remove the clay pocket. The indelible pencil marks and natches will have been transferred to the base of the plaster block and so centring will be simplified.

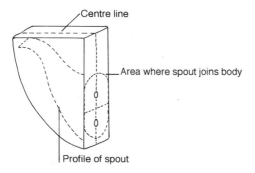

Guidelines for spout drawn on block.

5. Work the block by cutting flat the vertical and horizontal planes. Take care not to damage the join area. Once tidied up, mark the desired shape and central guidelines onto this block. Rough out the shape as previously described.
6. As the block slowly starts to take the form of the spout, remember to replace the guidelines, in particular the central one because omission of this can lead to twisting. Pare the shape away as you did with the handle, remembering to present the spout to the body frequently.
7. When the desired shape has been reached, finish off with wet and dry paper.

Undercuts

The draw, or the draft of the mould can be placed into two categories:

1. Drop-out moulds – where a mould draws away in one direction. This

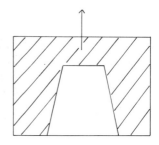

Direction of draft for a drop-out mould.

requires the model to be undercut - free and usually tapered, or, at least, having the rim or top of the form being its widest point.
2. Multi-part moulds – where a mould is constructed in several parts or pieces which individually draw away in different directions. This type of mould allows for more complex and intricate models, both in form and in surface. For example, a model with undulating ridges would require a two, or more, piece mould to facilitate the draw. See diagram below.

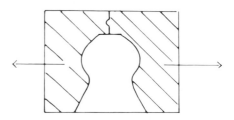

Direction of draft for a multi-part mould.

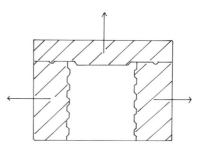

Direction of draft for a ridged surface.

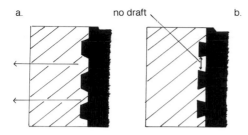

a. no draft b.

a. Detail of ridges *without* undercuts.
b. Detail of ridges *with* undercuts.

When making a model, consideration should be taken as to which kind of mould it will require. This is not to say that the moulding requirements should dictate the design of the model, although sometimes in industry this is the case for economic reasons.

When plaster is poured *over* a model to produce a mould, it grows warm to the touch as it expands away from the model and eventually, on cooling, shrinks back to just a fraction bigger than the model. Some schools of thought suggest it is easier to remove the model from its mould whilst the plaster is at its hottest point, and therefore in its most expanded state. However, I have found it safer to wait until the plaster has totally cooled before removal as it is very difficult to tell when the plaster has reached its maximum heat, short of waiting with your hand on the mould constantly. The main point is not to try and remove the plaster too early, as it is still in a fragile state.

Conversely, when plaster is poured *into* a mould, or cavity, for example, when reproducing a model from a mould, expansion will still occur. In this instance, however, the freshly poured plaster is not really allowed to do its work fully due to being contained, or 'locked in' by the mould walls – if the model is straight-sided, the removal of the plaster is impossible and then 'splitting off' the mould is the only solution. It is a common and necessary technique which is described in full detail in Chapter 5.

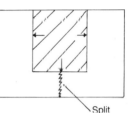

Swell of plaster in cavity encouraging cracking or splitting.

If the model has well-tapered sides then it can be removed with a bit of encouragement, although it can take up to several hours to cool down before removal is possible.

Mouldmaking Part I

Spares

Prior to moulding, an important element needs to be considered – the 'spare'. A spare is literally an extension of plaster added to the model to facilitate moulding. It also serves as the pouring hole for the slip. After moulding, it is through this opening that the slip is poured and subsequently emptied once the desired cast thickness has been achieved. If there was no spare on the model, the top edge, or rim, of the cast would be very uneven as there would be no reservoir to top up the level of the slip as it slowly drops during casting.

Spares are generally made from clay or plaster discs which are a tapered cone shape. As a spare will necessitate extra mould bulk whether it is incorporated in the mould or separate, consideration of size is necessary.

It is preferable to turn the spare on a lathe. Incorporate a slight angle as this will aid removal from the mould. If you do not turn the spare on a lathe, a small block of plaster can be fairly quickly hand carved or, failing that, a clay wall

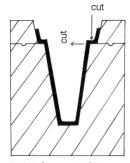

Angle of spare.

1. Without spare before draining

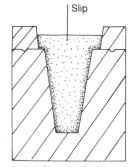

2. Without spare after draining

The difference of moulds with or without a spare.

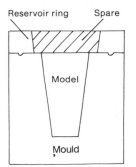

3. Model and mould with spare

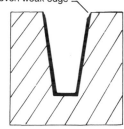

4. With spare before draining

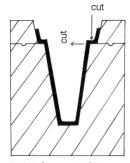

5. With spare after draining

will suffice. However, it is less neat and tidying up in the mould will be necessary.

A shorter spare has the advantage of requiring less mould bulk but the disadvantage is that, if too short, the level can drop too quickly during casting and an uneven cast will result, particularly when using slow casting slips, e.g. 20–30 minutes. A taller spare, however, will avoid the problem described above but naturally it will require mould bulk. The ideal size is somewhere between the two, measuring $1\frac{1}{4}$ to $1\frac{1}{2}$ inches (3–4 cm).

A decision needs to be made as to where the pouring hold should be if in an irregular form and, depending on the shape, what type of spare will be required i.e. 'outside' or 'inside' fitting or a 'plug' (see Chapter 5). Most multi-piece moulds require 'base' spares (see diagram).

Outside fitting spares (i.e. fitting outside the form)

For a simple, open vessel form such as a vase or cylinder, an outside fitting spare is advisable. In this case, a neatly cut edge is possible every time, also variable thicknesses are possible.

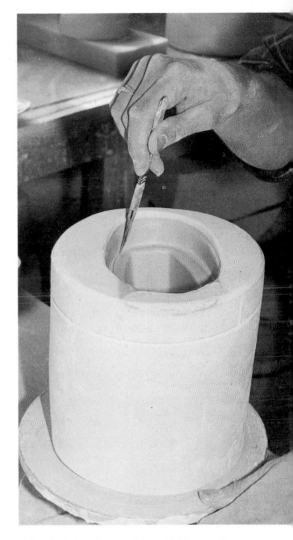

Cutting off an 'outside fitting' spare.

After draining the mould upside down, the spare is cut away. *Photograph by Ron Adams.*

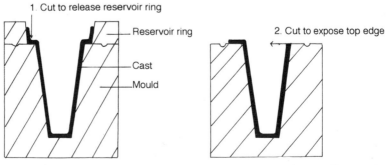

After draining

Removal of reservoir ring and cutting-off spare slip.

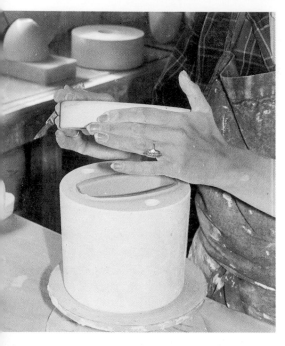

The reservoir ring is removed. *Photograph by Ron Adams.*

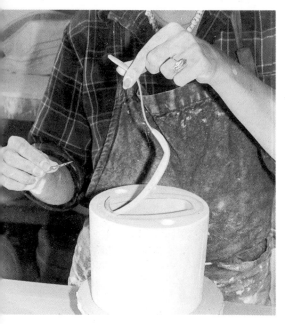

The excess slip is cut away and the top edge of the cast is exposed. *Photograph by Ron Adams.*

Inside fitting spares (i.e. fitting inside the form)

This type of spare is necessary in certain cases if a constant thickness is essential, for example, in batch production, when a container is to receive a lid, or if a form flares out at the rim.

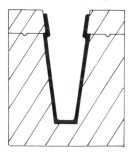

Cut using reservoir ring as guide

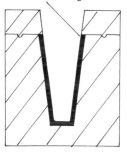

Sponge back overhang

Cutting off an 'inside fitting' spare.

Base spares

A base spare will be necessary in multi-part moulds where the model has a curved profile near the base of the form. If you do use a base spare, the part of the mould produced will be weak and, being fragile, it will break off eventually.

	ADVANTAGES	DISADVANTAGES
Inside - fitting spares.	-Variable thickness of cast if desired.	- More tidying up needed at finishing stage. - crucial timing needed when casting as overhang can be messy.
Outside - fitting spares.	- clean neat rims, very little finishing needed.	- ripping of edge or rim if blunt knife is used.

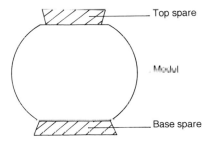

1. Model with 'top' and 'base' spare.

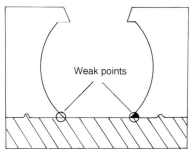

2. Mould *without* 'base' spare.

3. Mould *with* 'base' spare.

Advantages and disadvantages of the two types of spares.

Left
The necessity for 'base' spares.
After moulding the two sides, the base spare is removed carefully and the base (part 3 of the mould) is made.

Simple drop-out moulds (with outside fitting spare)

A model which tapers towards the base with no undercuts can usually be simply moulded in a one-piece drop-out mould with a separate reservoir ring.

If the model is made from plaster, there is a simple test to ensure that the model will drop out easily. It is to use a metal ruler, or straight edge, and rub an indelible pencil along the edge. Then place the model upside down on a piece of glass and run the ruler at right angles around the piece, checking where any blue indelible marks are picked up on the model. If there are any marks higher than the inverted rim, then there will be some undercuts and modification will be needed or the model will require moulding as a multi-piece mould.

49

Checking the draft.

Method for making a drop-out mould

1. After checking the draught of the piece, place the model upside down on a turned plaster disc or 'spacer'. Ensure that the spacer is wide enough to allow at least $1\frac{1}{4}$–$1\frac{1}{2}$ inches (3–4 cm) extra around the model to accept the mould. The spacer acts as a support for the model and provides a flat top to the mould.
2. Soap up the model and spacer three times.
3. Centre the model and secure it with a few drops of UHU. Allow the glue to set. Then place some cottling plastic around the spacer, ensuring that there is enough height for

Making a drop-out mould with an outside-fitting spare.

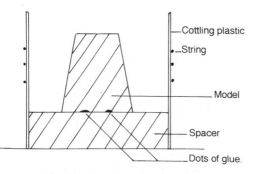

a. Secured model bedded on spacer with cottling in place.

clearance of the model. Then secure it tightly with string.
4. Mix up the plaster. It is better to over-estimate, rather than under-estimate, the amount needed, as any excess can be used to make a plaster bat. Too little means another mix will be necessary plus the new mix will be harder than the previous one.

Pour evenly aiming in between the model and the cottling. When the plaster has been poured, tap the side of the cottle to encourage the air bubbles to rise to the surface.
5. Allow the plaster to set and then remove the cottle. Tidy up by chamfering the edge with a surform knife – this takes off the sharp edges. Prepare to pour the reservoir ring.
6. Turn the mould the right way up *without* removing the model. Centre

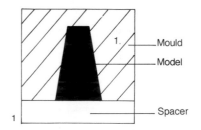

b. After soaping all the plaster surfaces, pour plaster into the cottle to make the mould 1.

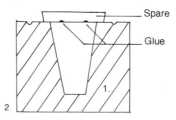

c. Place spare as central as possible over the model and trace around with an indelible pencil. Remove the make natches. Soap up plaster surfaces and replace spare secured with glue.

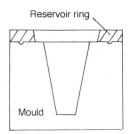

Reservoir ring

Mould

d. Place a shorter length of cottling sheet around the mould and pour plaster between the spare and the cottling to make the reservoir ring.

a pre-formed spare on top of the mould and ensure that it covers the model by $\frac{1}{2}$ inch (1 cm) at least all the way around. With an indelible pencil, trace around the position of the spare and remove it. You will then have a guide as to where to place the 'natches' or registration points. Remove the spare until the natches have been made.

7. Natch making

Natches are made by using a coin

Making a natch and positions.

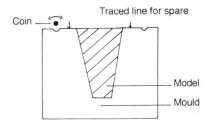

Coin — Traced line for spare

— Model

— Mould

Cross-section of mould

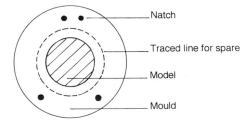

— Natch

— Traced line for spare

— Model

— Mould

Plan view of top of mould

Making a natch using a coin. *Photograph by Steve Hook.*

and driving it into the top of the mould using a semi-circular movement, twisting from side to side until the coin makes a half-sphere indentation. Make two together and two apart – this facilitates placing after removing the reservoir.

Plastic natches exist. However, the disadvantage I have found with them is that they locate very tightly into each other. This makes the removal of the reservoir ring difficult as snatching can occur. This in turn can rip and deform the cast edge.

8. Soap up the mould three times. Remember to include the spare and to secure it to the top with a few drops of glue. Allow the glue to set and place a smaller piece of cottling around the mould. Mix up a smaller amount of plaster and pour it carefully between the cottle and the spare. It is advisable to use a jug, in this instance, for easy pouring.

Soft-soaping the top surface of the mould prior to placing the spare and making the reservoir ring. *Photograph by Ron Adams.*

9. When set, remove the cottle and wait until the plaster has cooled down before trying to de-mould. Then, carefully remove the spare from the reservoir ring by gently tapping it in the direction of the taper. Place the ring upside down on the bench to avoid damaging the natches.
10. To release the model from the mould, turn the mould upside down and place your hand underneath to catch the model as it drops. The model should slide out provided the piece has been well-soaped and is tapered enough. However, if there are problems the following techniques can be applied:

 a. Place a weight or metal disc on the base and tap sharply with a rubber mallet.

 b. A trickle of water run between the model and the mould can lubricate the sides.

 c. If the model has a very slight taper, giving the appearance of being straight-sided, then the mould will grip around the model making it virtually impossible to remove. In cases such as this, a very small air-hole can be drilled into the base and an airline, using compressed air, can be applied into the hole encouraging the model to move. Alternatively, a small nail can be placed on the base of the model prior to moulding and, providing it is not covered by plaster, it can be removed after the plaster has set to create the air-hole.

 d. If the model is definitely stuck and none of the above methods have succeeded, then as a last resort two screws can be driven into the top of the model at an angle and then, by pulling the screws with a pair of pliers, the model can be prised out of the mould.

 This situation normally indicates that there has been a fundamental error – either 'bad soaping,' i.e. the model is too dry which means the soap is absorbed and therefore does not create a seal; the soap is too thin and is therefore absorbed into the model or, there is an undercut and the model, in fact, required a multi-part mould.

When the mould is finished, chamfer the sharp exterior edges and place in the drier. Ensure that the drier does not exceed 40°C. The mould should be dry in a couple of days. Depending on the size

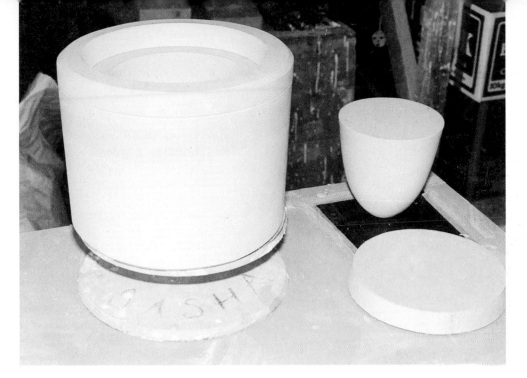

The finished mould with the removed model and spare (note chamfered edges). *Photograph by Ron Adams.*

and, if time is not a problem, then the mould can be left to dry at room temperature for a week or so. Slow, even drying is preferable as force drying can scorch the plaster and eventually it will break down, finally turning back to powder. Drying on, or in, kilns is not recommended.

Finding the centre line

Use either a plaster bat placed on a banding wheel, or a whirler head in motion, and mark a series of concentric circles. Draw a line through the centre dot dividing the circle in two halves. Set the compass at 2 to 3 inches (5 to 7.5 cm), and mark two points equidistant from the centre line on one of the circles. Centre the model on the plaster. Using a compass and an indelible pencil first

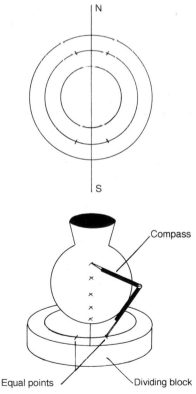

Finding the centre line.

make an arc on the model from one of these points. Keeping the compass the same size, make a mark from the other point. Where the two arcs cross will be the start of the centre line. Altering the size of the compass, make further crosses up the full length of the model.

Rotate the model and carry out the same exercise for the other side. A line can now be drawn vertically through the centre of the crosses, dividing your model exactly in half. Use a flexicurve if the model is curved or a straight-edge if the model is straight-sided. In cases where the model has a very undulating profile, place the crosses very close together and join them up by hand.

Multi-part or piece moulds

Models which are more complex and will not draw out from a drop-out mould require a mould to be made in several pieces. This will avoid undercuts and facilitate removal.

A basic multi-part mould will be comprised of two sides, a base and a top or reservoir ring if the piece includes an outside-fitting spare. If an inside-fitting spare is required, then this can be incorporated into the side pieces and a 3-piece mould will be necessary.

Method for making a multi-part mould with inside-fitting spare

1. Prepare the spares for the model (top and base).
2. Soak the model, if dry.
3. Find the centre line.
4. Soft soap the entire model and spares, and attach them to the top and the base of the model with glue.
5. Always make a mould on a board which is big enough for the model

and finished mould (allow $\frac{7}{8}$–$1\frac{1}{4}$ inches (2 to 3 cm) around the model).

6. Place the model on its side with rolls of clay underneath and adjust until the centre line is level.
7. Cut the plaster bats to fit the profile of the model and spares. Cut one for each side. These can be roughed out with a bandsaw and then finished by hand with a knife and rifflers. At the point where the profile meets the model, it is better to cut the bat at an angle as this makes final small adjustments of fit easier.
8. Soft soap the bats when finished.
9. Lay rolls of clay across each other along each side of the model about a $\frac{1}{2}$ inch (1 cm) below the centre line.
10. Take the plaster bats and gently press them down until they become level with the centre line – check with a spirit level. Any gaps between the bat and the model can be filled with a small coil of smooth clay. Use a square-ended tool to gain a 90° angle between the model and the profile bat. Take care not to scratch the model.
11. As the model and the bats will have been touched periodically during the setting up, another coating of soap is necessary. This time once is enough as the plaster has already been 'faced up'. Take care to remove any surplus soap from the angles using a small paintbrush.
12. Assemble the walls around the bedded model. These can be made from thickish plaster bats which have been cut to size and soaped, or wooden boards. The outside seams should be sealed with clay and

Right
Making a multi-part mould with inside-fitting spare.

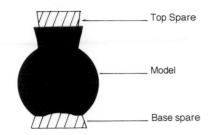

a. Model with spares (No. 1).

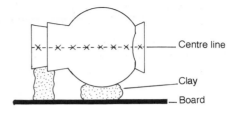

b. Centred model supported on clay (No. 6).

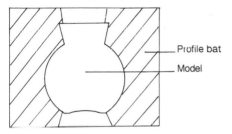

c. Profiled plaster bats cut to fit model (No. 7).

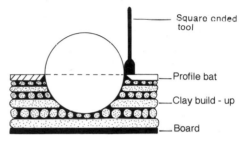

d. Clay build up and tool filling gaps between model and profile bats (No. 10)

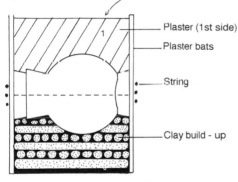

e. Plaster is poured into assembled bats to make first side of mould (No. 12).

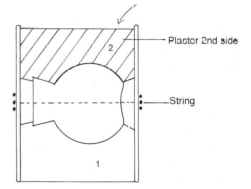

f. Model and mould turned over and plaster is poured to made second side (No. 14).

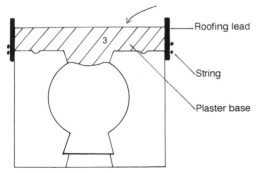

g. Base spare is removed and plaster is poured into roofing lead walls to make third part of the mould. (No. 3 Base section.)

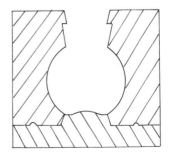

h. Finished multi – part mould

Assembled plaster bats (note tightly secured string with wedges for tension). *Photograph by Steve Hook.*

string tied around the outside. Wedges made from plaster or wood should be slotted in between the string and the bats to give it tension. Mark a depth of $1\frac{1}{4}$ inches (3 cm) above the highest point of the model onto the inside of the walls to indicate the depth to be poured.

13. Mix up the required amount of plaster and pour. When the plaster has set, remove the walls and clean up the outside of the mould with a metal kidney or surform, if necessary.

14. Turn the mould and model over and remove the clay bed and plaster bats. Ensure that the model is not disturbed until all the parts of the mould have been completed. If, by any chance, the model does get displaced then, when the plaster for the second half is poured, the swell of this plaster will force the two halves apart leaving a gap in the seam.

15. Make the registration natches using a coin as described previously. Place two together on one side and two separately or mark one differently from the others.

16. Soap the model, mould surfaces and the plaster bats and reassemble, allowing enough depth again above the model. Pour the second half.

To make the base

1. Keep the sides together and place up-ended. Remove the base spare with care.
2. Make natches and soap up the entire area.
3. Cottle around the base and run the final piece of the mould. In many cases it is easier to place a flexible cottle, either roofing lead or felt, around the mould and secure with string and wedges as previously described, rather than to struggle with reassembling plaster bats or wood without help.
4. Finish and dry in the same way as the drop-out mould.

An alternative method of making the base part of a multi-part mould is to make what is termed a 'locking bottom'.

This is a piece of plaster which is turned in the same way as the base spare, i.e. taking the same dimensions from the foot. However, it doubles up as the 'third' part of the mould at the same time and cannot fall out due to its form. See diagram.

If an outside-fitting spare is required, make the reservoir ring following the same method as for the drop-out mould.

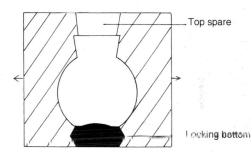

'Locking bottom' alternative.

Mouldmaking Part II Specific Techniques

Split moulds

If the model has a smooth profile, without intricate detail, but is of such a shape that it will not drop out, then a quick method of making a two-piece mould can be achieved by making it in the form of a drop-out mould, i.e. pouring plaster over the up-ended model, and then splitting the mould in two.

To achieve this, score the mould by

sawing approximately $\frac{3}{8}$ inch (1 cm) all the way around the middle of the mould. Then place a sharp knife, or stiff metal palette, between two scrapers on the score line and hammer the knife sharply. This will send a vibration along the score line and the mould will split open.

This technique of splitting is used in other methods, namely when the plaster is poured into a mould or cavity of plaster and the expansion of the plaster inside prevents removal. 'Splitting off' the mould is therefore the only solution and is a necessary procedure when 'blocking and casing'.

Split mould (open) with base (note the saw mark along the edge).

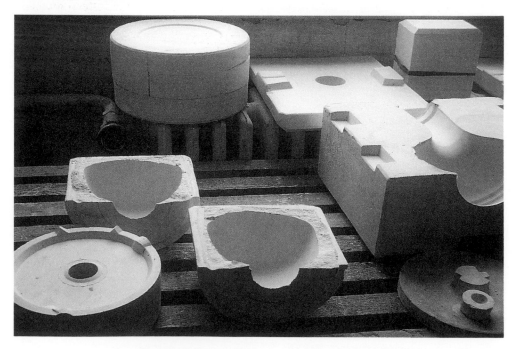

Blocking and casing

This technique is usually linked with production mouldmaking in industry or small batch production for the craftsperson. It is a means of reproducing identical moulds and minimising the wear on the original model by way of intermediary models and moulds. Most craftspeople make just one mould from the original model and cast directly into that. When producing a limited edition of 10 or 20 pieces, this is perfectly adequate. If, however, an indefinite number of casts are required from that mould, the gradual deterioration of the interior surface will eventually render the mould useless. Therefore, small batch production requires several moulds from the same model.

I will endeavour to illustrate this method simply for a studio situation. However, for further reference on a larger scale in connection with industrial reproduction, I suggest reading *Mold Making for Ceramics* by Donald E. Frith and *Plaster Mold and Model Making* by Chaney and Skee. To quote from Chaney and Skee, a description for 'blocking and casing' is as follows:

> As a term, block and case always refers to the special mold used to duplicate a mold section. The *block* is the portion of the mold which corresponds to the *inside* of the original model mold and thus forms the inside of the production mold. The *case* is the portion which forms the *outside*, or the walls, of the production mold.

To block and case a simple drop-out mould with a reservoir ring

1. Prepare model for moulding on a plaster bat and remember to soap up three times between each stage.
2. Pour plaster over model to form model mould and continue, as usual, for the reservoir ring. It is usually at this stage that casting can take place if only a few pieces are needed. If, however, more moulds are required, the following stages are necessary:
3. Pour plaster into the mould. This mould will then require splitting off due to the swell of the new plaster. This then is termed a 'waste mould'. The second 'model' is then called a *block*. Repeat this process for the reservoir ring.
4. A *case* is made in plaster from the original model mould (Stage 2). This serves as the outside walls of the proposed mould. As they have been made in plaster, they are easily replaced and re-used. Alternatively, plastic cottling will suffice. Repeat this for the reservoir ring.
5. Pour the two elements and place together to create the 'working mould'. It will naturally take the same form as the original model mould, or waste mould, but will be fractionally bigger resulting from the swell of the plaster.

To produce further moulds, refer back to Stage 4 and soap up *once* between each pour of plaster as the surface has already been faced up.

If the block and case break down, subsequent blocks can be made by going back to Stage 3 using the waste mould which can be secured with wire and re-soaped once between each run of plaster.

Blocking and casting a simple drop-out mould with a reservoir ring.

Model

Model mould

1

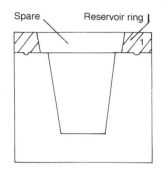

Spare Reservoir ring

1

a. Model (positive) (No. 1).

b. Model mould or Waste mould (Negative) (No. 2).

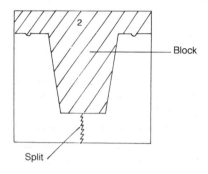

2

— Block

Split

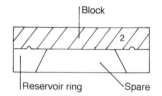

Block

2

Reservoir ring Spare

c. Block (positive) (No. 3).

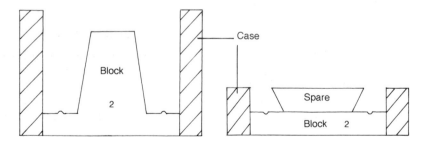

— Case

Block

2

Spare

Block 2

d. Case or outside walls (No. 4).

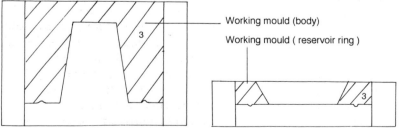

3

—— Working mould (body)

Working mould (reservoir ring)

3

e. Working mould (Negative) (No. 5).

Modelling and moulding a container with inside fitting lid

There are various types of lids. However, a typical symmetrical lid fitting is described in the following cross-section:

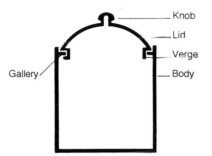

Container with inside-fitting lid.

Lid (see diagrams on page 62)
1. Turn the body of the model with a gallery to accept the lid model.
2. Turn the lid model *without* its verge so that the lid can be tried in the gallery of the body before cutting off from the lathe. This allows for adjustments or another lid to be made if it is not correct.
3. Turn a separate lid verge approximately 1 cm ($\frac{3}{8}$ inch) smaller at least (0.5 mm ($\frac{1}{32}$ inch) each side) than the lid. Glue it to the underside of the lid.
4. Turn the spare for the lid approximately two cast thicknesses narrower than the verge, tapered in the other direction. Glue spare to the underside of the verge. The lid is now ready for moulding.
5. Soap up all the elements. If casting in an earthenware slip, include the knob and mould the lid in two parts with a vertical seam line. Remove the spare as this creates the pouring hole.

6. If casting in bone china or porcelain, model and mould the knob separately. Mould the lid in two parts but this time with a horizontal seam along the edge which is the widest point of the lid. This hides the seam line (to be discussed further in Chapter 7).

Body (see diagrams on page 63)
1. Mould the body of the container leaving the top free.
2. Make a tapered spare to fit into the gallery of the container with a bottom diameter *slightly* wider than the top of the lid verge by approximately 5 mm ($\frac{1}{4}$ inch) i.e. 2.5 mm either side to allow for a glaze thickness and some play. This spare acts as the pouring hole as well as creating the hole to accept the lid verge.
3. Make natches and soap up all parts and centre up the spare on top of the gallery. Glue onto the body model. Cottle up and pour in the plaster to the top of the spare. Remove spare when set.

Modelling an irregular lid which sits flush in the form
(see diagram on top of page 63)

A form which is not interrupted by the lid i.e. a continuous line, can be achieved by using the following method:

1. Mark with an indelible pencil the opening in the top of the body which is to accept the lid. Carve out by hand using rifflers and knives to the desired depth of the lid. (See page 64.)
2. Lay a thin layer of clay into this recess. The clay acts as a glaze thickness of approximately 2 mm ($\frac{1}{8}$ inch) as it takes into account the glaze thickness on both the underside

Modelling and moulding a container with an inside-fitting lid.

a. Turn the body of the model with a gallery to accept the lid model (No. 1).

b. Turn lid model without its verge (No. 2).

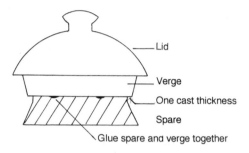

c. Turn lid and tapered verge separately. Make verge 1 cm smaller than lid (0.5 cm each side) No. 3.

d. Turn spare for lid approximately 2 cast thicknesses smaller than the verge.

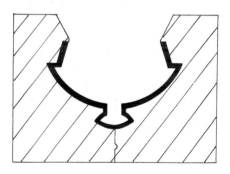

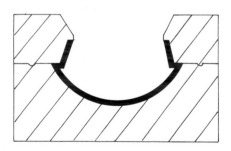

f. For bone china or porcelain, model and mould separately. Mould lid with horizontal seam line (No. 6).

e. Lid mould in two parts for earthenware casting including knob (No. 5).

of the lid and the top of the gallery on the body.
3. Pour a small amount of plaster into the clay-lined recess. As it sets, use a flexible metal kidney to scrape down carefully over the top of the body and make a flush join.
4. Make a separate verge and spare for

the lid as described previously. This time, however, as it is done manually, mark with an indelible pencil line the measurements for the verge at its widest point and soap up the underside of the lid. Place a clay wall around the outside of the line and pour a small amount of plaster into

Moulding the body of the container.

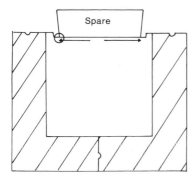

1. Mould body of the container leaving top free. Tapered spare fits into gallery with bottom diameter slightly wider than top of lid verge (No. 1 and 2).

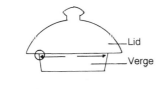

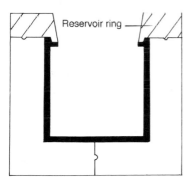

2. Finished mould showing reservoir ring making gallery in the casting stage (No. 3).

this. Remove the plaster when set and carve by hand to produce a verge with a slight taper towards the base.
5. Repeat the process for the spare tapering in the other direction and take into account the cast thickness. Stick all the elements together with glue and model a locating 'lip' onto

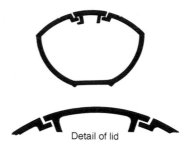

Detail of lid

Container with lid sitting flush in the form.

the base of the verge in clay. Mould as described above.
6. Make the spare for the body, which in turn creates the gallery, using the same method described above, remembering to increase the dimensions by approximately 0.5 mm ($\frac{1}{32}$ inch) all the way around. This time, however, it will be poured and hand carved in the same way as the verge and lid spare have been. (See diagrams on top of page 65.)

Moulding a handle (see bottom of page 65)

1. Seam the handle model to find the centre line. Prepare a plaster bat and lay the handle on top of it, drawing around the profile. Drill a small hole into the bat on the inside of the profile line, then, with a coping saw, cut out the shape of the handle.
2. Place the handle into the bat, adjusting with clay underneath so that the handle sits halfway at seam height into the bat. Alternatively, if the handle is very small, a flat clay bed can be built up to the centre line instead of using a plaster bat.
3. Once bedded, fill all the gaps between the bat and the handle with clay as described in the chapter on multi-part moulds (Chapter 4). Add half a clay spare, at either end of the handle,

Modelling and moulding a container with lid sitting flush in the form.

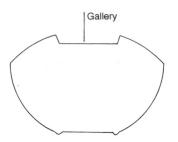

1. Gallery is carved out by hand (No. 1).

2. Plaster is poured into clay-lined gallery to make lid model (No. 3).

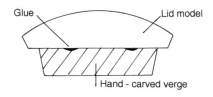

3. Detail of lid and hand-carved verge (No. 4).

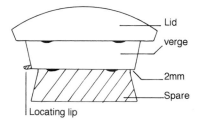

4. Lid and verge with hand-carved spare (No. 5).

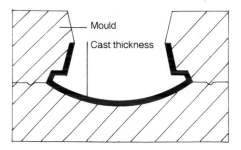

5. Lid mould with horizontal seam-line.

soap up and place a cottle around it, then pour the first side.

4. When the plaster has set, turn the mould over and remove the clay or plaster bat build-up, making sure not to remove the handle model. Make a couple of small natches and build up the other halves of the clay spares. Soap up and cottle up, and pour the second side.

5. After the plaster has set, remove the

clay spares and the handle. If the handle is very thin and delicate in section, it is common for the handle model to break when removing it from the mould. This is not a problem during casting as the shrinkage of the slip will facilitate removal, although this should be done sooner rather than later to avoid contraction around the interior part of the mould.

Moulding a spout

When casting in earthenware, the spout can be incorporated in the body mould, particularly if it is a coffee pot where no 'grid' is required (this is a pre-formed piece of slip which has holes pierced in it and serves to strain the tea leaves). This is introduced into the mould during the casting stage (this is explained in more detail in Chapter 6).

Moulding the body of the container.

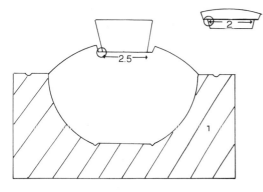

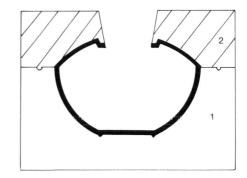

1. Part mould body of the container, leaving top free. Tapered spare fits into gallery with bottom diameter slightly wider than top of lid verge (No. 6).

2. Finished mould showing top part of mould (2) making the gallery in the casting stage.

Moulding a handle.

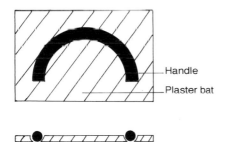

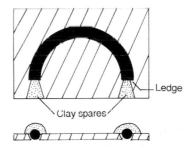

a. Handle model is set halfway into plaster bat (No. 1 and 2).

b. Add halves of clay spares leaving a ledge for joining onto the body (No. 3).

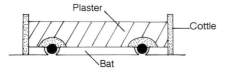

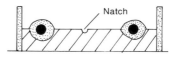

c. Cottle up with clay walls, or small plaster bats and pour first side (No. 3).

d. Turn mould over, make natches, build up other halves of spares, soap up and replace cottle (No. 4).

e. Pour plaster for second side.

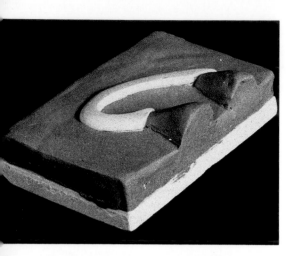

Handle model bedded in clay ready for mouding (note spares). *Photograph by Steve Hook.*

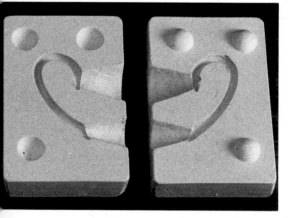

Finished handle mould. *Photograph by Steve Hook.*

When casting in bone china or porcelain, the spout is normally moulded separately. The 'sticking up' of the spout to the body of the teapot is done at the leatherhard stage and a grid is pierced into the body at the jointing point of the proposed spout. In the case of it being moulded separately, the spout is usually divided vertically (which helps with lining up when casting) and a 'bulb' of clay is added to the model either at the base of the spout, or at the top, depending on the shape of the spout in question. The bulb is necessary because, by casting into an enclosed mould, air is likely to be trapped. Any air bubbles, therefore, can escape into this extra area and not interfere with the casting of the spout. In addition to this, when casting, the bulb becomes waste and if placed approximately 3 mm ($\frac{3}{16}$ inch) (a casting thickness) inside the edge of the base of the spout, this will serve as the cutting edge for the join. Likewise, the spare is added to the opposite end to where the bulb has been placed (see diagram).

Follow the same method as for moulding a handle using a plaster bat to fit around the profile of the spout and include the bulb and spare.

Below
Spout mould showing two different ways of placing the 'bulb'.

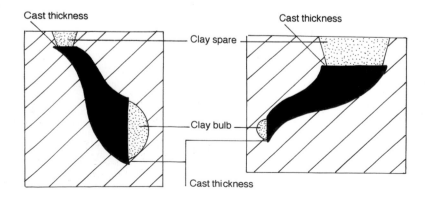

Double casting and floating

A double cast form is where both surfaces, inner and outer, are formed by the mould with a solid layer of slip in between, i.e. two cast thicknesses together, hence the name 'double cast'.

If small i.e. for saucers etc., the model can be turned from plaster on a lathe, and then a mould can be made directly from the plaster model. However, this requires a certain amount of skill in turning to ensure that an even thickness of plaster is achieved. One way of doing this is to work with a bright spotlight positioned behind the model as plaster can be semi-translucent when thin and so varying degress of thickness can be detected.

Selection of slipcast fruit by Penkridge Ceramics made using the plugging method.

An alternative method of double casting is to use the 'floating' method. It is as follows:

Double-casting and floating to make a plate mould.

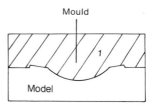

1. Turn the inside form on a whirler, or lathe, if the form is small i.e. saucer etc. and remember to include the cast thickness of the rim (No. 1).

2. Soap up and pour the first side (No. 2).

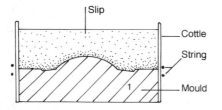

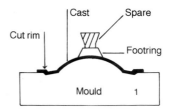

3. Allow mould to dry out and then place a cottle tightly around the mould. Pour slip over the mould and allow to cast up for approximately 45 mins – 1½ hour depending on the dryness of plaster and required thickness.

4. After draining the slip, tidy up the rim and place a turned footring made from plaster, or clay, on top of the form. Include an inside-fitting spare on top of the footring.

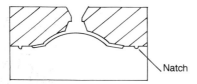

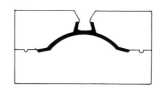

5. Make natches and soap up all plaster areas three times. Place a cottle around mould and pour second side, or back of the mould. This will form the underside of the object. After the plaster has set remove, the old cast, footring and spare.

6. After the mould has dried completely, cast as normal. During casting the two sides of the mould will cast up to form a double-cast. The footring will be open and single cast.

Plugging

This method is used to create the impression of a solid form and is particularly useful when moulding natural objects, e.g. fruit etc. (see Chapter 8 – Penkridge Ceramics).

Method of plugging using a two-piece mould

1. Bed the model in clay with plaster bats on top to ensure tight seams.
2. Cottle up and pour the first part of the mould. (1).
3. Turn the spare, which doubles up as the 'plug', to fit into the footring and make finger holes for easy removal. Pour the second part of the mould. (2).
4. Cast and drain the slip as normal and cut-off the spare.
5. After leaving the slip to harden up slightly, refill with a *small* amount of slip and replace the plug.
6. Rotate the mould quickly, the added slip will cast up over the plug inevitably causing some thicker areas at the base. This method is more suitable for lower firing slips where differences of thickness are less obvious.
7. After removal of the cast from the mould, make a discreet airhole into the base when the cast has hardened up.

Moulds and cast of miniature toilet by Ann Shepley (note double-cast area).

Moulding a form using the plugging method.

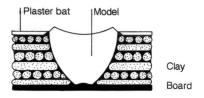

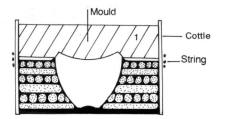

1. Bed the model in clay with plaster bats on top to ensure tight seams.

2. Cottle up and pour the first part of the mould (1).

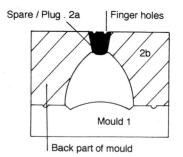

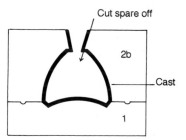

3. Turn the spare, which doubles up as the 'plug', to fit into the footring and make finger holes for easy removal. Pour the second part of the mould (2b).

4. Cast and drain the slip as normal and cut off the spare.

6. Rotate the mould quickly, the added slip will cast up over the plug inevitably causing some thicker areas at the base.

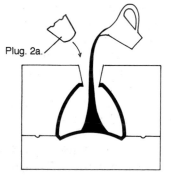

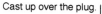

5. After leaving the slip to harden up slightly, refill with a small amount of slip and replace the plug.

7. After removal of the cast from the mould, make a discreet air-hole into the base when the cast has hardened up.

Chapter Six
Slipcasting

Use and types of deflocculants

Caroline Whyman states in her book on *Porcelain* the following:

> A good workable casting slip should not shrink too much from wet to leather-hard, and it must have good dry strength. It must remain in suspension without settling out and, most importantly, must be sufficiently fluid to pour into and out of moulds using a minimum amount of water aided by a deflocculant.

Deflocculation means the retaining of a *high density* but *fluid slip*. Deflocculants aid the dispersion of particles in the slip which in turn leads to increased fluidity and therefore less water is required. They also assist particle suspension and reduce comparative shrinkage in a body mixture. This is obtained by the addition of *electrolytes*, which are alkalis, in silicate (usually sodium) or in carbonate (soda ash) form. If a clay already contains *free alkali* it will not deflocculate. The electrolyte alters the charges on the molecules, or clay particles, causing them to repel each other which in turn renders the slip fluid.

The most commonly used deflocculants are:

1. Sodium silicate[1]
2. Soda ash/sodium carbonate[2]
3. Calgon
4. Dispex (manufactured combination of sodium silicate and soda ash). Usually used to adjust slips.
5. Darvan 7 (American equivalent of Dispex). This has the advantage of not being easily absorbed into the mould, thus prolonging the working life of the mould.

The alkalis can affect the properties of the slip, not only its fluidity and *thixotropy* (the thickness of the slip on standing) which is the plasticity factor, but also its hardness. They can be used in varying proportions to suit a particular body and give a final cast required properties. There are no laid down amounts of alkalis to be used however. With earthenware for example, it is usually 0.25% of the *dry* body content and rarely exceeds 0.5% as too much deflocculant will make the cast very brittle and difficult to trim.

The behaviour of the slip, providing the moulds are constant, will depend on the degree of deflocculation. A rough guide to slip control is as follows:

[1]There are various strengths of sodium silicate depending on the ratio of sodium to silica. The ratios are referred to as degrees Twaddle e.g. 70 degrees, 100 degrees or 140 degrees TW. The higher the degrees TW, the thicker the liquid. This is a system for denoting the *specific gravity* of a liquid, e.g. degree TW = (s.g. (specific gravity) − 1) times 200.

[2]Most commonly used in conjunction with each other.

Control methods of slip

1. Pint weight (density)
2. Fluidity
3. Thixotropy These are affected by the condition of the alkali.

The water content of a porcelain casting slip, for example, should not exceed 50% by weight of the dry ingredients and may be as low as 25%. The lower the water content, the more casts can be taken from a mould before it becomes saturated. This also means that fewer dissolved materials are absorbed into the plaster – occasionally, when a mould has been used a lot and has dried out, a furry substance appears on the surface. These are the salts which have worked their way out through the pores in the mould and form soda crystals. (See later in this chapter for more details.) The hardness and the softness of the water also has an effect on the slip.

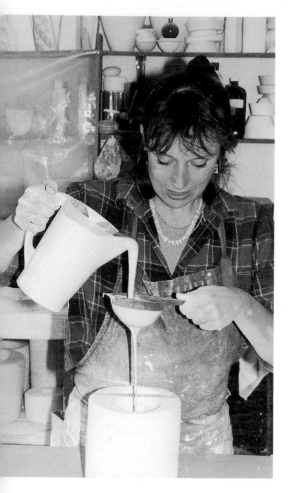

Pouring slip through a sieve into a mould. *Photograph by Ron Adams.*

1. Slip casts too rapidly and casts are flabby – add *more* deflocculant.
2. Slip casts too slowly and casts are dense and brittle – use *less* deflocculant.
3. Slip casts at correct rate but is too viscous[1] (resistance to flow) – add very small amount of water to correct fluidity, or *Dispex* to adjust.

[1]Potclays are now marketing an American product called a Slip – Testing Kit which includes a viscometer (an apparatus which determines the viscosity of a slip).

Casting slip recipes and casting times

Manufacturers will provide recipes for casting slips on request (see List of Suppliers for addresses). Those detailed below provide a guide to some typical recipes:

1. WHITE EARTHENWARE	*Firing range*	*Casting time*

50 kg earthenware plastic clay 1000–1150°C 20–30 min
5.5 g sodium silicate 100° TW
22.5 g soda ash
4.25 litres of water

2. RED EARTHENWARE

75 kg terracotta plastic clay 1000–1150°C 20–30min
100 g sodium silicate 140° TW
80 g soda ash
9 litres of water
If adjustment is required, add 100 g of Dispex at the end.

3. STONEWARE

75 kg buff stoneware plastic clay 1160–1290°C 45 min – 1 hour
175 g sodium silicate 140° TW
37.5 g soda ash
11 litres of water
If adjustment is required, add 200 g of Dispex at the end.

4. SEMI – PORCELAIN or HIGH FIRING WHITE EARTHENWARE

75 kg semi – porcelain plastic clay 1100–1260°C 20–30 min
15 g sodium silicate 140° TW
37.5 g soda ash
7 litres of water
If adjustment is needed, add 20 g of Dispex at the end.

5. BONE CHINA

50 kg bone china plastic clay 1220–1260°C 2–7 min
65 g sodium silicate
4.5 litres of water

6. PORCELAIN (Geoffrey Eastop's)

5.90 kg china clay 1260–1280°C 5–10 min
2.04 kg flint
3.29 kg potash feldspar
1.36 kg BBV ball clay
0.23 kg bentonite
32 g sodium silicate
6.82 litres of hot water

Method for preparation of a casting slip

Keep one litre (1.8 pints) of the water a side and place the rest into the blunger. Carefully weigh out the amounts of sodium silicate and soda ash and dissolve them in hot water using the reserved litre of water. Add this mixture to the water already in the blunger and introduce the clay. If using plastic clay, add small quantities until the required amount has been introduced into the slip – some ceramicists prefer to add a bag full, in small quantities, every half an hour. If using powdered clay, then add the required amount to the water in one go – this is sometimes easier than using plastic clay, although not all clays are available in powdered form. Blunge thoroughly for approximately $1\frac{1}{2}$ – 2 hours before use. If no blunger is available, and only a small quantity of slip is required, then a rapid glaze mixer will suffice. Allow to stand for a while and if the slip appears too thick, add a few drops of Dispex to adjust the fluidity depending on the recipe. Recycling of the casting slip scraps is possible, provided the reclaimed slip does not exceed 20%. Exceeding this amount can cause problems due to the imbalance of deflocculants.

Potterycrafts recommend an addition of 0.1% of barium carbonate to the slip to remove the sulphates which can cause peeling faults during glazing.

Slip casting stages:

Stages		Key points
1. Mould preparation	i)	Always ensure the moulds are *dry*.
	ii)	*New moulds*: Moisten the seams when parting to prevent nipping of the slip.
	iii)	Sponge inside to remove loose bits and excess soap which could be left from the mouldmaking. It is usual practice to discard the first cast from a new mould as it will pick up any bits of plaster still present on the surface and can result in the piece exploding during firing.
	iv)	*Old moulds*: Check for clay bits between the parts before assembling.
	v)	Check for damage to moulds.
	vi)	Assemble all parts, using a) wire hoops for large moulds or b) inner tube bands for small to medium moulds. These will prevent the mould seams from opening when the slip is poured.
2. Mould filling	i)	Speed of filling *Too fast*: a) casting spot, b) swirl marks, c) pinholes, d) blips *Too slow*: a) filling lines, b) variation in thickness

in quick-casting slips e.g. bone china and porcelain.

 ii) *Position*

Attempt to direct the slip to the centre of the base of the mould. If the slip is allowed to run down the side of the mould, a *casting spot* can occur down the side of the article. This creates a 'hard spot' in the cast, which is particularly apparent in coloured bodies, can discolour and be resistant to glaze. Filling through a cone sieve 40s mesh, or small plastic cooking sieve will help.

 iii) If the piece is large, the mould can be revolved on a banding wheel whilst filling. This keeps the slip agitated and avoids filling lines. If the piece is narrow in section, i.e. a saucer, the revolving of the mould avoids any air bubbles which might be trapped whilst filling.

 iv) Whilst the piece is casting up, in particular if the form is very large, the slip may need agitating before tipping. This can be done by stirring the slip inside the mould with a soft bristle paintbrush while taking care not to touch the sides.

3. Casting times

This is governed by many factors e.g. type of body, size of mould, consistency of slip etc. For further details on casting times refer back to earlier in the chapter.

4. Tipping

 i) Tip out *steadily* into a bucket using a circular motion swilling the remaining slip around in the mould. This will increase the fluidity of the slip and it will drain more evenly from the mould, leaving a smooth surface on the inside of the cast.

 ii) *Too slow* – draining marks occur.

 iii) *Too fast* – sucking in is likely to occur, especially with narrow-necked pieces. Beware of a 'glugging' sound. This will result in flabby, distorted casts, which have pulled away from the sides.

 iv) If the mould has not been secured in any way, opening of the mould at the base whilst tipping causes flabby casts as well as the possibility of leaks.

5. Draining	The angle of the drain is important (approximately 30°–40°).
	i) *Too steep* – 'droppers' or 'stalactites' will occur on the inside of the base.
	ii) *Too shallow* – draining wreathes or variations in thickness will occur.
	NB: Reversing the mould *during* draining is sometimes necessary to even up the thickness of certain areas, e.g. teapot galleries etc.
6. Reversing the mould	i) *Too soon* – the slip can run back leaving drips in the mould.
	ii) *Too late* – if the piece is a drop-out form with an outside-fitting spare, it can quite simply fall out. If the piece is in a multi-part mould then, depending on the shape, contraction can occur around areas of plaster in the mould as the cast dries.
7. 'Scrapping' or cutting out the spares	i) *Too soon* – bits can fall inside and stick to the inside of the cast which is still wet.
	ii) *Too late* – the cast becomes too hard resulting in small cracks.
	NB: Care should be taken to avoid cutting the moulds with sharp knives which could result in thin tops. Conversely, cutting with blunt knives will cause cracking of the rims.
8. 'Flannel back' or sponging top	This is normally associated with earthenware only. After cutting, the edge is pressed back with a damp sponge or piece of chamois leather. This prevents any cracking if the edge has been opened up with a knife. Also, reversing the direction of the sponging closes up any cracks which might have appeared, i.e. cut in clockwise direction, sponge in anticlockwise clockwise direction. Rough edges can be smoothed out.
9. Emptying or removing cast from mould	i) *Too soon* – results in distortion of the cast.
	ii) *Too late* – can lead to cracking of intricate shapes, e.g. teapots with handles and spouts cast on.
	iii) For earthenware, empty moulds approximately 30 min. – 1 hour after tipping to avoid distortion.
	iv) For bone china, it is a good idea to leave the casts in the moulds overnight to lessen the

chance of distortion. However, this does mean the slip has longer contact with the mould which can have a breakdown effect on the surface of the plaster thereby causing premature mould erosion.

v) If casts do not release easily, i.e. in the case of saucers and awkward shaped objects, dust the mould surface, prior to casting where the sticking occurs, with either talc or ground porcelain or bone china.

Procedure for emptying a 3-part mould:
i) Remove wire or inner tube band.
ii) Lift the two side halves together off the base.
iii) Place on its side on the work surface.
iv) Remove the top half side and replace on the base.
v) Lift the remaining half and remove the cast whilst holding in the vertical position.
vi) Place the remaining half of the mould on the base.
 NB: It is important to place the mould pieces back together immediately to avoid damaging any of the parts.

10. Fettling and sponging

When the cast has dried to a leatherhard or 'green' state, remove the seam lines with a fettling knife or scalpel and sponge.

11. Placing of handle 'bittings' or spout grids (for teapots or coffee pots)

Generally speaking, earthenware casts are made with a handle and spout *cast on*, i.e. incorporated in the mould. This, however, depends on the shape, particularly of the handle, as an elaborate form could lead to contraction problems and therefore timing is crucial for the emptying of the cast from the mould.

Bone china and porcelain handles and spouts, on the other hand, are normally cast separately from the body and *stuck on*, providing care is taken to ensure a compatible state of leatherhardness for all the elements, i.e. handle, spout and body.

'Sticking up' is done with a 'water' slip (casting slip mixed with water to a slurry) and not with just casting slip as it is too thick.

Forms, therefore, with *cast on* handles and spouts require handle 'bitting' and spout 'grids' as described below:

For handle bittings:

Prior to casting, suspend a pre-formed piece of clay, or press clay, into the bottom of the handle once the mould has been assembled. During casting the handle will cast up solid – for obvious reasons, hollow handles are not a good idea with hot liquid running through them.

For spout grids

Prior to casting, prepare a pre-formed piece of slip and, at the leatherhard stage, cut a shape which is fractionally smaller at the sides than the base of the spout. Pierce the holes (approximately 7) and make them fractionally bigger than required. Suspend the grid in the mould by tacking top and bottom with some slip. Pour in the slip and as it fills up through the spout area the slip will pass through the holes, making them slightly smaller, and around the sides thus sealing the grid in place. Care needs to be taken to ensure the slip is not too thick so that there is no risk of closing up the holes. Re-piercing, after casting, is sometimes necessary.

Finishing, fettling and mould erosion

Finishing and fettling

Providing the moulds are still fairly new and the interior surface has not become pitted or eroded, then there should be little finishing required, except on the rims. With earthenware casts, as previously mentioned, the rims are usually sponged, after cutting, whilst they are still in the moulds. Once the casts have been removed, the entire surface can be sponged, if necessary, whilst still leatherhard.

Fettling is an industrial term used for trimming excess clay away from the seams. A 'fettling' knife is a particular tool normally made from an old hacksaw blade with its teeth sharpened off.

Bone china or porcelain casts, however, should be treated with a bit more care to minimise the risk of warping because any movement or accidental knocking whilst damp will encourage warping during firing (see Chapter 7). The casts, therefore, should be allowed to harden up, ideally overnight, in the moulds and then, upon removal, the rims sponged. Once the casts are bone dry, they can be sanded using a piece of felt or fine grade wet and dry paper (used dry). A respiratory mask should be worn for protection. Alternatively, work in a spray booth.

If the casts are particularly thin, they will be extremely fragile at this stage. Therefore, it is a good idea to introduce a soft firing to approximately 1000°C and then sand them down afterwards with a fine grade wet and dry paper (used dry). Afterwards a damp sponge can be wiped over to remove any dust. Again wear protective masks as the soft fired clay dust is hazardous.

Handle 'bitting' and spout 'grid'.

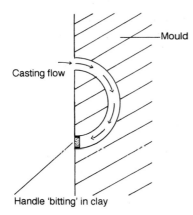

1. Handle 'bitting' *before* casting.

2. Handle 'bitting' *after* casting.

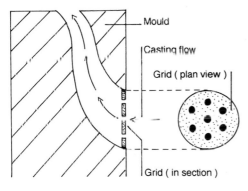

3. Spout 'grid' *before* casting.

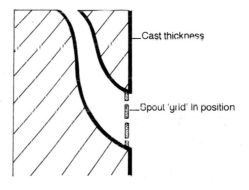

4. Spout 'grid' *after* casting.

Mould erosion

The moulds will normally wear out and become pitted after 30–40 casts. This erosion is due to the deflocculants, or soluble salts, present in the casting slip which gradually open up the pores of the inside of the mould. It is as well to discard the mould when this happens. However, if the form is still to be reproduced, a new mould can quite simply be made from the old one using the 'blocking and casing' principle. Briefly, soap up the interior of the used mould three times and pour in fresh plaster up to approximately 3 cm ($1\frac{1}{4}$ inches) above the top of the mould including the top surface and the natches. This will produce a new and slightly expanded model or positive. The used mould will require 'splitting off' and the model can be sanded down in preparation for re-moulding. (For a fuller explanation, refer back to Chapter 5.)

After standing and drying out, well-used moulds which have become saturated can develop off-white furry salt crystals on the interior and exterior surfaces. This is commonly termed a 'salt bloom' and is caused by the soluble salts

79

which are present in the slip, the plaster and in the water, working their way through the pores in the mould during drying. It is particularly noticeable in older moulds. To avoid this happening on the mould face, dry two moulds together, or upside down, so that the face is not exposed. This will force the salt crystals to work their way out to the exterior or back of the mould.

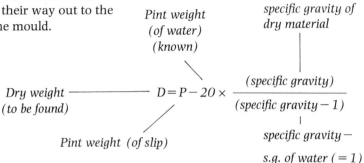

For *imperial* weights use the following:

i) To find the *dry weight* of material contained within a known *slop* (water and powder mixture):

Brongniart's Formulae

There are several formulae based on Alexandre Brongniart's original one which are particularly useful in determining various requirements. For example:

i) the *dry weight* content of a slip
ii) the *water content* of a slip
iii) to reduce the *thickness of a slip*
iv) to keep the *density of a slip* static

The above are useful to know if the slip needs adjusting for various reasons. They particularly apply, for example, when colouring a slip where body stains or oxides are to be added. Between 2–20% of body stain can be added to a slip depending on the density of colour required.

To enable specific, repeatable trials to be carried out, the dry weights of all the ingredients need to be established and the formula is as follows:

ii) For US capacities where 1 pint of water weighs 16.705 oz. the formula is as follows:

$$\text{Dry weight} = (\text{oz. pt} - 16.7) \times \frac{\text{S.G.}}{\text{S.G.} - 1}$$

iii) For metric capacities where 100/cc of water weighs 100 g, the following formula applies:

$$\text{Dry weight} = (\text{slip weight} - 100) \times \frac{\text{S.G.}}{\text{S.G.} - 1}$$

Assuming that 100 cc of slip have been weighed in grams, then this is called *slip weight* – the weight of the dry content being also in grams.

Method

First weigh the container empty, then weigh it with one pint[1] of the slip to be

[1]See appendix for conversion chart.

80

tested. The liquid weight is arrived at by subtraction, using the formula as follows:

$$D = 32 - 20 \times \frac{(s.g.)}{(s.g. - 1)}$$

$$= 12 \times \frac{2.5}{2.5 - 1} = \text{(The average specific gravity of plastic clay is 2.5)}$$

$$= 12 \times \frac{2.5}{1.5} \text{ or } \frac{5}{3} = \frac{60}{3} = 20$$

therefore: *D = 20 oz (dry weight)*

ii) To find the *water content* of a slip:

 D − P = water weight of slip

iii) To reduce the *thickness* of a slip:

 A − B = (Existing pint weight − required pint weight)

 B − 20 − (Required pint weight − pint weight of water)

For example:
 The slip weight at present is 28 oz. and it needs reducing to 24 oz:

$$\frac{28 - 24}{24 - 20} = \frac{4}{4} = 1$$

Therefore 1 oz. of water must be added to every 1 pint of slip to keep the thickness static.

iv) To keep *density of slip static* (in storage):
This is done by altering the volume of material added.

$$\textit{Formula} = \text{depth of material} \times \frac{\text{density of slip one day}}{\text{density of slip another day}}$$

$$\text{i.e. depth} \times \frac{\text{density of slip A}}{\text{density of slip B}}$$

All materials are kept in slop, or wet form, in store and they are mixed in quantities to give a known dry content. Should the density of the slip vary e.g. 24 oz. / pt one day and 25 oz. / pt another day, then the volume of the material being added must be altered.

Method

Measure the depth of the vessel in which the dry weight will be added, e.g.

$$12 \text{ inches at } \frac{24 \text{ oz./pt}}{25 \text{ oz./pt}}$$

$$= 12 \times \frac{24}{25}$$

$$= \frac{48}{5} \qquad = 9\tfrac{3}{5} \text{ inches}$$

Troubleshooter chart for faults in slipcasting

Fault	Description	Cause		Remedy	
Pinholing	Small holes just beneath the surface (on the mould side of the cast) and sometimes inside surfaces of the casts.	i)	Fluidity too low.	i)	Increase water addition.
		ii)	Trapping air either in manufacture or when draining the cast.	ii)	Knock air bubbles to the top. Allow slip to stand overnight. Drain cast evenly.
Wreathing	Small uneven ridges on slip side of the cast.	i)	Thixotropy too low.	i)	Decrease alkali addition.
		ii)	Uneven draining of slip (likely to occur in slips with fast casting rate e.g. bone china).	ii)	Drain evenly and steadily.
		iii)	Due to uneven porosity of the plaster of the mould.	iii)	Aim for even mixture of plaster.

Fault	Description	Cause	Remedy
Brittle casts	Hard, brittle casts which are difficult to cut or fettle.	Thixotropy too low.	Decrease alkali addition.
Flabby casts	Soft casts difficult to handle without distortion.	Thixotropy too high.	Increase alkali addition.
Casting spot (flash mark)	Dense vitreous areas at point where the slip hits the mould. Discoloured patch appearing on the mould side of cast *after* firing (problems when glazing as vitrification occurs on this spot).	i) Thixotropy too low. ii) Where the slip hits the mould there is a separation of clay particles – the 'mica' particles, which are flat, align themselves in one direction.	i) Decrease the alkali addition. ii) Try and hit a surreptitious point in the mould. iii) Sponge the face of the mould with a thin layer of slip if very bad.
Livering	Slip appears jelly-like and thick.	i) Can be due to over-contact with the air. ii) Too much alkali / soluble salts. iii) Plaster contamination.	i) Keep slip in an airtight container. ii) Decrease alkali. iii) Avoid contamination.
Cracking	Small cracks where the handles join the body of the piece.	i) Thixotropy too low. ii) Added when one, or other element is too dry.	i) Decrease alkali additions. ii) Ensure the two elements are of the same dampness
Bad draining	Slip failing to drain from narrow sections.	i) Fluidity too low. ii) Thixotropy too high.	i) Increase the water content. ii) Increase the alkali addition.
Slow casting	Casting time too long.	i) Fluidity too high. ii) Thixotropy too low.	i) Decrease the water. ii) Decrease the alkali addition.

Casting shop in JPM porcelain factory, St Yrieix, nr. Limoges, France.

Chapter Seven
Bone China

Brief historical background and development of bone china

Bone china manufacture was derived from porcelain. It was originally a simulation of the porcelain which was manufactured on the Continent in the 18th century and can best be described as an English hybrid between soft-paste and hard-paste porcelain.

Porcelain originated in China *c.* 618–907 AD, during the Tang Dynasty and was later developed in the 14th and 15th centuries during the Ming dynasty. It was a naturally occurring clay in China as opposed to the hard-paste porcelain which was developed by Ehrenfried Walther von Tschirnhaus, Johann Friedrich Bottger and Pabst von Ohain at Meissen in Germany in 1709. This was a composite body of clays namely:

> Kaolin (china clay)
> Alabaster (later replaced by feldspar)
> Quartz

It was the Europeans who described it as 'porcelain' derived from the Portuguese word 'porcellanous' meaning 'shell-like'. The Chinese considered it to have a

Pierced bowl by Angela Verdon. *Photograph by John Cole.*

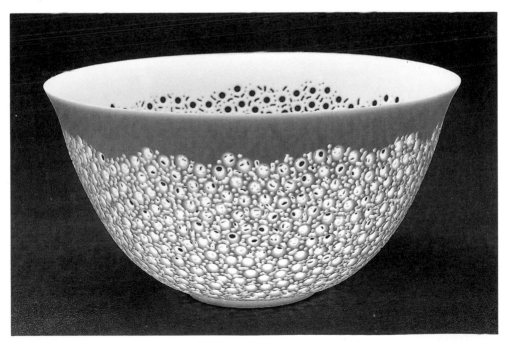

85

wider definition than is generally accepted in the West. It could be *any* fine, pale body of primary clay which had a distinctive ring to it when tapped.

The earliest recorded experiments to recreate the Chinese porcelain in Europe were attempted in the 1570s by Francesco Mario de Medici in his alchemical laboratory in Florence. In France, porcelain was first made in Vincennes in 1740 and was then later transferred to Sevres. A glassy frit was used as a *flux* instead of feldspar thus distinguishing the early French manufacture from other European porcelains.

In 1745 several factories were experimenting with the development of a 'porcelain' body, for example, Pomona, Limehouse, Chelsea, Derby and the Bow in London where they introduced bone. In these early types, a glassy frit was used similar to the French ware. This, however, made it very difficult to work and coupled with the very refractory and unplastic nature of English china clay, the successful manufacture of porcelain was very inhibited.

By 1747 the production of bone ash had begun but it was not until 1749 when Thomas Frye of the Bow works (London) patented, for the second time, the use of bone ash, that any headway was made into the development of a relatively high-fired white clay or 'china'. However, there was still inclusion of frit in the body at that time. Finally in 1794, Josiah Spode initiated the change to the present mixture of *bone* ash, stone and *china* clay, originally termed 'Stoke China' and latterly *Bone China*. This dispensed entirely with the use of frit and resulted in a body which, used in conjunction with slipcasting, paved the way to modern manufacturing methods in England.

Technical information

Bone china is a very white, translucent body with great strength, resembling porcelain in appearance but not in coldness nor structure when fractured.

The calcined bone forms approximately half of the body. Dora Billington gives the following recipe:

bone ash	40
china clay	32
china stone	28

Additions of ball clay or bentonite are liable to discolour the body and lessen the translucency, if added in large quantities.

This is a particularly 'unplastic' body and cannot be successfully worked by hand unless it is thrown very quickly and thickly and subsequently turned down to a thin wall. Or, as is more usually the case, slipcast.

Bone ash was originally imported from Argentina, Holland and Sweden, the best bones being shin and knuckle from beef cattle. The bones are first boiled and the residue sent for glue manufacture, after which they are calcined, ground and introduced to the china body.

Basic recipe for a plastic bone china body

Bone ash	50%
China clay	25%
Cornish stone	25%

Standard firing temperatures
Biscuit – 1250°C + 1½ hr soak
Glaze – 1080°C

N.B. Small amounts of ball clay i.e. 1 – 2% can be added to increase the strength and plasticity of the body without affecting the colour too much.

This is a dense, white vitreous (less than 1% water) translucent body.

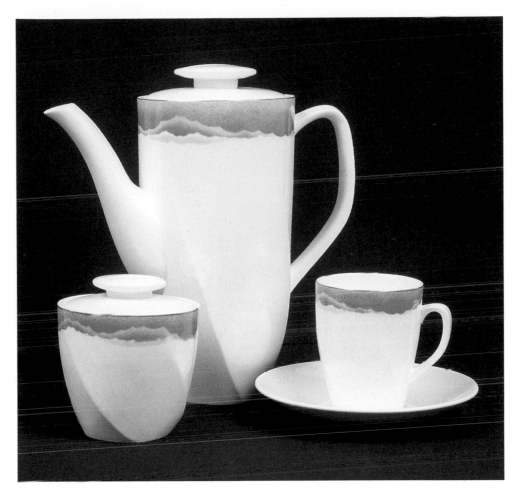

Coffee pot by Sasha Wardell, 1981 (note seamlines following twist).

Basic recipe for a plastic porcelain body
China clay	50%
Feldspar	25%
Flint/quartz	25%

Standard firing temperatures
Biscuit – 1000°C
Glaze – 1280°C–1400°C

This is a dense, cream or ivory vitreous, translucent body.

High losses have always been an accepted part of china manufacture thus making china production very expensive. The chief difficulties encountered are the following:

1. A short firing range.
2. The tendency of bodies to go 'off-colour'.
3. High shrinkage on firing (which can be up to 15%).

1. The problems encountered with a *short firing range* are considerable warping. This is because as soon as the body reaches its 'eutectic' temperature (the lowest melting point of two or more substances), substantial quantities of liquid are

formed rapidly which can cause the body to deform and become misshapen.

As much as 40% of the body may liquefy quite rapidly at the eutectic point. Therefore, the only way to combat this is to increase one of the components such that the composition of the body falls further away from the eutectic temperature.

Bone china is notorious for what is familiarly called it's 'memory'. Intentional warping can be controlled by knocking or denting the ware in the damp state and then attempting to reshape it. These dents or warps will reoccur during the firing in the same place – the body having remembered. A method of controlling the 'warping factor' is described in detail later in this chapter.

2. The tendency to go '*off-colour*' needs to be avoided if the essential character of bone china is to be retained, i.e. its whiteness and translucency. The bone ash content needs to be increased, although this can cause difficulties elsewhere – it is easy to envisage the problems likely to happen when reducing the clay content of a body which has little plasticity and poor working properties as it is. Consequently, the addition of a small percentage i.e. 1–2% of ball clay is necessary to increase plasticity and strength. However, as previously

mentioned, too much can cause the body to go 'off-colour'.

3. Depending on the high biscuit temperature, i.e. between 1220–1260°C, the shrinkage will be greater the higher the firing. It can therefore be between 10–15%.

Model and mould requirements

1. Size

Due to the high shrinkage of this body, allow for approximately 12% (average%) larger than the desired finished size when making models. This can be achieved very roughly by adding 12% *proportionally* to the model at the plaster stage, i.e. if the finished height is to be 20 cm make the plaster model 22.4 cm to take into account the shrinkage.

2. Compensation curve

This should be introduced at the model stage to combat the flattening out, dropping or sinking which occurs at the high firing stage. For example, if a flat-sided piece is required then a *slight* convex curve should be introduced. This will flatten out slightly in the firing as

Compensation curves.

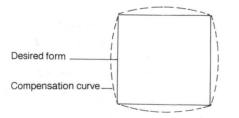

Desired form

Compensation curve

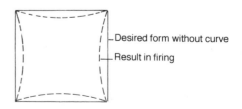

Desired form without curve

Result in firing

Left
Plan view of model *with* compensation curve.

Right
Plan view of model *without* compensation curve.

opposed to pulling in, which would result in a concave curve. Similarly, with footrings a slight curve inwards is necessary to avoid sinking or dropping in the firing.

3. To avoid seam lines

Ideally, if a form can be made where the model will withdraw directly from the mould then naturally, there will be no seam lines. If, however, a form necessitates a multi-part mould, then it is a good idea to design the form with a twist, facet or edge where a seam could be placed during the moulding stage. This will avoid the problem of seams reappearing during the firing, however carefully they have been sanded down during the fettling stage. This phenomenon is caused by the mica particles in the clay aligning themselves wherever there is an irregularity or gap, however small, in the mould. This alignment creates a thicker or raised area which cannot be avoided in a high-firing clay.

It could be argued that the techniques dictate the form to an extreme in this instance. However, in some cases just a small change of detail or, the introduction of an edge, is all that is required to alter what could be potentially a complicated multi-part mould to a much simpler drop-out mould with very little fettling required on the cast.

4. Scale

Scale is limited using bone china for a couple of reasons – mainly the collapsing of open forms during firing and the physical problem of manipulating a large, heavy mould whilst draining the slip.

If the model is higher, for example, than 50 cm, then warping and falling in on itself is a risk however well-supported the piece may be. Likewise, a mould which contains a form of these dimensions needs to be emptied very steadily and evenly, otherwise varying thicknesses will occur. To do this manually or unaided requires a lot of strength, especially in the back. Therefore the introduction of a pulley device can serve as an aid for particularly large items.

5. Handles and spouts

These are usually modelled and moulded separately and then added to the body at the leatherhard stage (see Chapter 5).

Casting, finishing/fettling and soft firing

Bone china requires a short casting time to achieve a good thickness – between 2–5 minutes depending on the size and the translucency requirements of the item.

To minimise the distortion factor, if possible, leave the casts in the mould overnight and remove them the following day. Allow to dry and then sponge the rims and remove any seam lines with a scalpel or fettling knife.

To avoid breakages and losses, a preliminary firing of 1000°C can be introduced. Subsequent sanding with wet and dry paper (using it dry) will achieve a very smooth surface and finally a barely damp sponge can be wiped over the entire piece removing any traces of fettling dust.

As well as reducing losses caused by breakages of thin pieces whilst fettling green ware, the inclusion of this

preliminary firing is useful if piercing is required. This can be achieved by using a small drill, either a glass engraving drill or dentist drill, after the soft biscuit. (See Chapter 8 – Angela Verdon.)

Setters

In cases where the biscuit firing is much higher than the glaze firing, it is essential that the clay ware receives the maximum support during the firing process, particularly as most of the movement will occur when the kiln reaches its highest temperature. Due to the high distortion factor encountered with bone china, and if the shape is to be

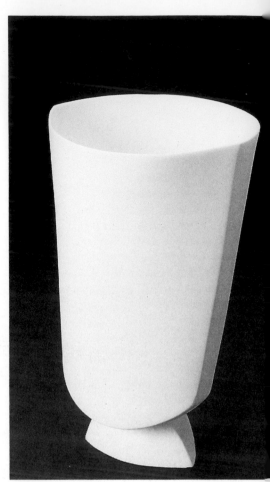

Above
Vase and base by Sasha Wardell, 1982, fired with setter.

Left
Vase and base by Sasha Wardell, 1982, fired without a setter.

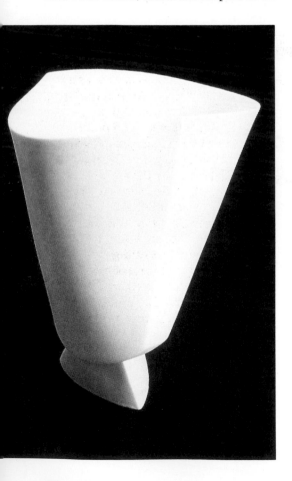

controlled, any open form requires a 'setter' of some description. In basic terms this is an item which resembles a lid and which is cast separately. Its function is to contain the top edge, or rim, of a form during firing. (See page 94 for details on making setters for irregular forms.) Compared to other

materials, using bone china is a costly process because most pieces require a setter, which takes up extra space and so the firing becomes more expensive. Conversely, however, because the kiln is packed more openly, it can be fired quicker than a tightly-packed kiln.

Saggars

In industry, the traditional way of firing bone china flatware, i.e. saucers, plates etc. was to use large saggars made from refractory clay with 50% grog added. These items were normally jolleyed or slipcast, the wall thickness being 20 mm ($\frac{3}{4}$ inch) and either oval, circular, oblong or square in form with rounded corners. The industrial norm for the dimensions of an oval were approximately 420 × 575 mm ($16\frac{1}{2}$ × $22\frac{1}{2}$ inches).

Up until the mid-1930s, the saggars were filled with flint. This was used as the supporting material for the form until the increased risk of silicosis and pneumonicosis was associated with this. Flint was then substituted with calcined alumina which was bedded down using a 'placer' (normally a fired-size plate). The purpose of this was to make a supporting mound of alumina which had taken into account the contraction of the plate by the end of the firing. The green, or unfired, plate would be placed upside down over the mound and more alumina would be packed over the top of

this – the plate being sandwiched in between.

In cases where the ware was less expensive, one plate would be placed on top of another, remembering to use an alumina wash (alumina and water) between the two surfaces to avoid sticking. This method is used less and less now as the risk of warping was fairly high and, in addition to this, when the saggars were stacked on top of each other, there would be a solid wall of ware to be heated and cooled. Subsequently, this meant a much longer firing and cooling period and, coupled with the advent of cleaner fuels, smaller kilns and continuous firings, the use of the saggar sharply declined.

2. Flatware

The method of supporting bone china flatware is to use what is known as a 'profile setter'. This is a refractory ring whose shape is such that it gives maximum support at the end of the biscuit firing where the most movement occurs. The form, therefore, does not require support under the plate – it is adequate enough just under the rim.

A coating of alumina wash must be placed between the setter ring and the ware to avoid adhesion during the firing.

In cases where the footring is *equidistant* from the middle of the plate to the edge of the rim, and where the rim is not too large nor too flat, the plate can survive being fired the right way up.

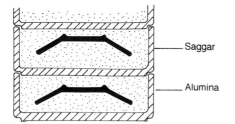

Plate in saggar sandwiched in alumina.

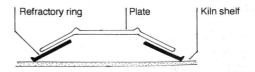

Rim of plate supported by refractory ring setter.

3. Cups

China cups or small symmetrical bowls are 'boxed' together which means placing the two pieces rim to rim, ensuring that the handles are lined up. Prior to this the rims should be washed with alumina and then glued with gum arabic which burns away in the firing.

Cups with handles which stand proud of the rim cannot be successfully fired in this way as pulling will occur due to the handles not being in line. In these cases an individual setter with a space for the handle cut out will be necessary. These setters are angled to allow for the movement of the cup as it shrinks up the setter during the firing. The cups can then be fired upside down or the right way up.

The method of boxing has the advantage of keeping the handles straight, saves on space in the kiln, stops distortion and reduces risks of handles being knocked off.

4. Holloware: Teapots, coffee pots and containers with lids

During the firing, handles and spouts will pull and distort the form unless the piece is fired with a lid. However, these items do not require any form of special setters as the lids of the objects serve as a setter in themselves. *NB.* An alumina wash needs to be added between the lid and the body.

5. Figures

These require individual treatment and awkward shapes can be supported by propping them with supports made from the same body or by completely bedding the piece in alumina powder, taking care not to trap the alumina in areas where

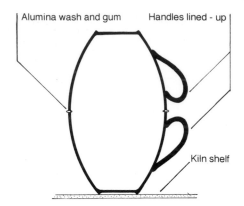

'Boxed' cups.

the contraction is likely to occur i.e. in between the arms, under chins etc.

Alumina is really the only material which can be used as a placing powder for bone china as silica sand, or a mixture of sand and alumina, would fuse together at 1260°C and cause a molten mass around the figure.

6. Flat tiles or plaques

To retain completely flat pieces, substantial amounts of alumina can be applied to cover and weigh down the piece during firing.

7. Open irregular forms

Almost any shape can be settered – it is not confined solely to symmetrical forms. The following diagrams illustrate the method of producing an irregular setter:

a. Fill the mould from which the setter is to be made with slip and cast as normal.
b. Drain the mould and remove the spare and reservoir ring:

Right
Porcelain plaque by François Ruegg (Switzerland).

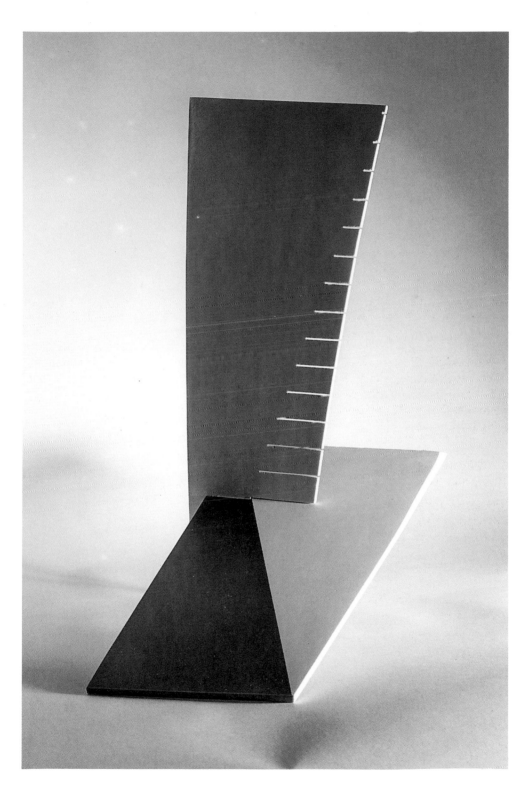

Method for making irregular setters.

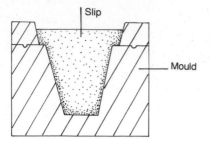

A. Fill the mould from which the setter is to be made with slip and cast as normal (a).

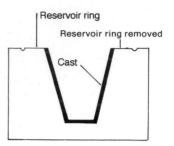

B. Drain the mould and remove the spare and reservoir ring (b).

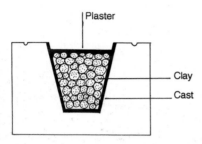

C. Fill the cast up with small pieces of plastic clay to approximately 1 cm under the rim. Smooth off the top of the clay with a small amount of plaster (c).

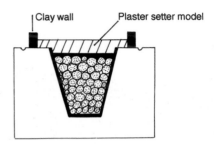

D. Soap up top of model, including the plaster inside the cast. Place a clay wall around the top to form the model of the setter. Pour plaster in (d).

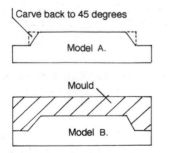

E. Once the plaster has set, remove model and carve back to an angle of 45 degrees taking care not to disturb the rim impression (e).

F. Soap up model and pour mould (f).

When the cast of the setter is removed from the mould, place it into the piece and dry together. Fire them together with an alumina wash between the rim and the setter (g).

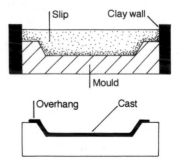

G. Cast and drain at the same time as the piece which requires setter. Release clay wall leaving overhang (g).

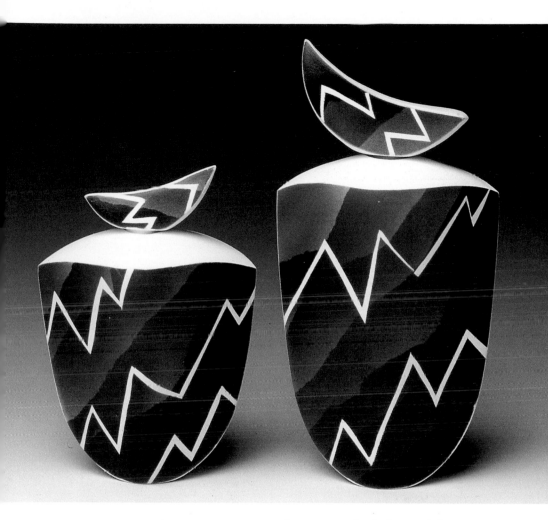

Stopper vases by Sasha Wardell. No setters required. *Photograph by Mark Lawrence.*

c. Fill the cast up with small pieces of plastic clay to approximately 1 cm (3/8 inch) under the rim. Smooth off the top of the clay with a small amount of mixed plaster.

d. Soap the top of the mould, including the plaster inside the cast. Place a clay wall around the top to form the *model* of the setter and run plaster into it.

e. Once the plaster has set, remove the model and carve back to an angle of approximately 45° taking care not to disturb the rim impression which has been picked up.

f. Soap up and place a clay wall around the model and pour the mould. When the mould has dried out, place clay walls around it and cast at the same time as casting each piece.

g. Cast and drain at the same time as the piece which requires a setter. Then release the clay wall leaving a overhang. When the cast of the setter is removed from the mould place it into the piece and dry together. Fire them together with an alumina wash between the rim and the setter.

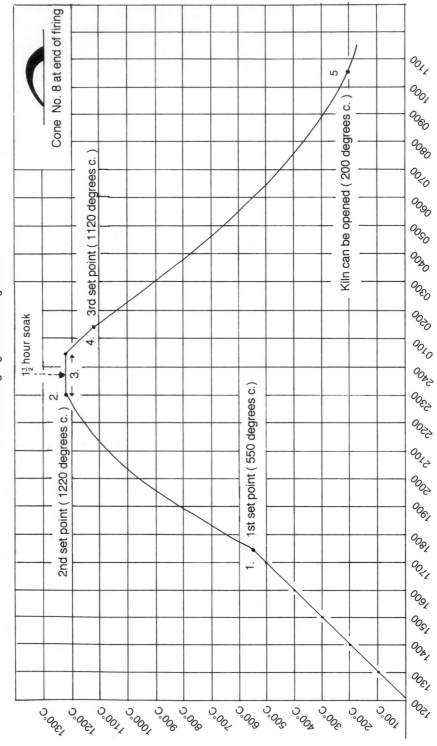

Chart showing high bicuit firing curve.

Cone No. 8 at end of firing

2nd set point (1220 degrees c.)

$1\frac{1}{2}$ hour soak

3rd set point (1120 degrees c.)

1st set point (550 degrees c.)

Kiln can be opened (200 degrees c.)

2.
3.
4.
5.
1.

1300°C
1200°C
1100°C
1000°C
900°C
800°C
700°C
600°C
500°C
400°C
300°C
200°C
100°C

Time (1200 - 1200)hrs

1200 1300 1400 1500 1600 1700 1800 1900 2000 2100 2200 2300 2400 0100 0200 0300 0400 0500 0600 0700 0800 0900 1000 1100

8. No setters

For some experimental forms, the firing of the ware without setters can lead to some interesting and unexpected shapes. Likewise depending on the form, warping can be less dramatic, and occasionally not at all, if there is some strength in the design.

Note: It is not necessary to setter china ware at the glaze firing stage as it has already reached its maximum temperature in the high biscuit and, therefore, is not going to move anymore.

High biscuit firing

Tradition has been that bone china was high-biscuit fired, i.e. to 1250°C approximately and then low-glaze fired to 1080°C approximately. This was due to a combination of economical and technical reasons. The economical one was that the majority of losses occur at the high-firing stage and so subsequent treatment is not necessary. The technical constraints were that if the firing order was reversed, i.e. low bisque and high glaze, to follow the treatment that porcelain receives for example, there would be much more chance of loss and distortion. The body moves to a great extent anyway at the high-bisque stage becoming progressively more vitreous and this would be greatly more exaggerated by the addition of a glaze which would cause extra stresses and tensions.

Due to the fact that there is very little silica present in bone china, and it is usually very thin, it is one of the very few clays that can be fired quickly up to and over the quartz inversion temperature

Left
Chart showing high biscuit firing curve.

of 573°C. In fact, it is possible to fire it within two hours provided the kiln is capable of this. However, the wear and tear on the elements and the kiln generally outweigh this advantage and so after careful firing experiments, the most satisfactory firing cycle I have discovered is as follows:

1. Controlled climbing of 100°C per hour to 550°C.
2. Bungs in at 550°C then kiln climbs at own rate to 1220°C.
3. Soak for $1\frac{1}{2}$ hours where the temperature rises to 1260°C (cone 8 acts as a guide).
4. Controlled cooling of 100°C per hour to 1120°C then allowed to cool at own rate.
5. Kiln can be opened at approximately 200°C.

Approximately 13 hours firing.
Approximately 22 hours from packing to unpacking.

If the kiln is equipped with a Cambridge controller, the set points which are available with this piece of equipment are very useful programming a bone china high bisque firing. Every kiln and controller or programmer differs – the accompanying graph is used with a Potterycrafts Top Loader (1.5 litre capacity) in conjunction with a Cambridge controller 201. It is a safeguard to use a cone as an indication of what has happened in the firing (Cone 8.)

The firing range for bone china is between 1220°C–1260°C. I have found after various trials that to achieve the best results that 1250°C with a $1\frac{1}{2}$ hour soak is the most successful combination.

If you fire to 1220°C, the forms will easily retain their shape but there will be

(continued on page 100)

Comparing bone china to porcelain

	Bone china	Porcelain
Composition	Bone ash, Cornish stone, china clay, ball clay	Flint, potash feldspar, china clay, ball clay, bentonite
Model and mould requirements	Certain forms require compensation curves at model stage, e.g. large flat areas need convex curves to allow for sinking during firing	The same
Casting	Casting times e.g. approx. 2–3 minutes for 3 mm ($\frac{1}{8}$ inch) thickness	The same
Firing temperatures	High biscuit – 1250°C + 1½ hour soak Low glaze – 1000°C–1080°C	Low biscuit – 1000°C High glaze – 1260°C–1400°C* *For vitrified pieces requiring no glaze fire directly to this temperature. (Exceptions – certain 1080°C glazes will adhere to high-fired porcelain bodies, therefore, having a similar firing pattern to bone china.)
Setting	Needs supporting or setting at high biscuit stage – not necessary at low glaze stage.	If no glaze is required and the pieces are fired straight to the top temperature, then setting needs to be applied in the same way as for bone china. If the pieces have been designed and produced with the least risk of warping, very little setting is needed, if at all, at the top temperature. Cups and symmetrically rimmed pieces can be 'boxed', however, the glaze needs to be wiped from the rim. Gum arabic is used to adhere the two rims together during firing. After firing, the two rims are highly polished and sealed where there has been no glaze. This is done using a series of grinding stones with a solution of glaze as a lubricant.

continued opposite

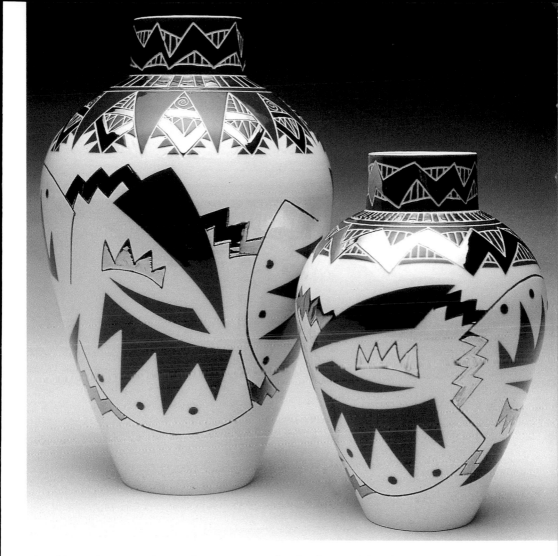

Glazed bone china vases by Caroline Harvie (Scotland). *Photograph by John P. Bisset.*

	Bone china	**Porcelain**
Glazing	Due to vitrification at the high biscuit stage, application of glaze can be difficult. Either heat the piece beforehand or add 1–2% of gum arabic to the glaze to help with adhesion.	Glazing is straight forward as it is applied at the soft biscuit stage.
Qualities and properties	Very white. Very translucent. Hard. Applied colours appear cleaner and truer due to the white base.	Off-white or ivory colour in oxidised firing. Blue / grey colour in reduction firing. Not as translucent. Harder and stronger. Applied colours can appear duller.

(*continued from page 97*)
little or no translucency. In fact, the body will have a slight pinkish hue which is an indication of under-firing. If you fire too high, i.e. 1260°C and above, there is a very increased risk of warping even if setters are used. Small, flatter pieces, however, can be packed in alumina and successfully fired to this temperature and above (1280°C).

Although I have found the optimum firing temperature, each kiln load results in 20% wastage. This is sometimes unavoidable as an uneven draining of the slip can occur which causes a thickening up of the slip in one area. This in turn, encourages pulling and distortion.

Glazing

Whilst bone china requires a very high biscuit temperature, it also has a low earthenware temperature glaze firing. It is not essential to include a glaze as the body has already obtained a vitreous state in the high biscuit. However, with functional ware, staining can be a problem and so glazing is necessary.

Due to the vitreous nature of this clay, pouring and dipping can be very difficult as there is no porosity in the body and so no absorption to help the glaze adhere to the body. In order to rectify the problem of no absorption, the addition of gum arabic to the glaze in proportions of 1–2% will introduce adhering properties to the glaze. Alternatively, heating the ware either in a kiln at 150°C, or in a drying cupboard, will assist in the glaze 'pick-up'. This enables the glaze to stay on the ware because the heat given off the body absorbs the water in the glaze.

Care needs to be taken not to heat the ware too much as the sudden change in temperature, when introducing a cold liquid to a warm or hot object, can cause thermal shock which will result in the ware cracking and splitting.

To increase the glaze pick-up, the thickening of the glaze can help. Spraying glaze on the outside surfaces of holloware is an easier solution, once the insides have been poured. However, layers of glaze need to be built up gradually. The problem here, however, is to ensure even thicknesses between the outside and the inside of the piece. Testing with a pin will give an indication of the thicknesses.

Chapter Eight
Individual Approaches

This chapter includes work of selected ceramicists who use slipcasting in a very personal way:

Jeroen Bechtold

Jeroen is a Dutch ceramicist who graduated from the Rietveld Academy in Amsterdam in 1981. As an undergraduate he worked for the Rosenthal Studio Line as a freelance designer and continued this until 1985 when he established his own studio and gallery. Here he pursued his work with porcelain using the traditional slipcasting method in a very experimental and exploratory manner, pushing the technique beyond its normal confines.

Although he finds casting, in itself, an essentially boring and repetitive technique, it is in fact indispensable to his current way of working. He states that: 'Casting provides a superb way of making an even wall on the pot, the same thickness all over and therefore no tensions in the clay itself.'

He has developed a series of techniques based on casting including multiple casting, casting and assembling, single casting and deforming in the mould or on removal and spray casting. He explains that:

Inlaid decoration is possible with double and triple casting. Determining the amount of time to allow between the layers is a matter of experience; variations in humidity and temperature within the studio are mitigating factors. Adjustments need to be made for these variances to avoid having the layers 'melt' into each other and leave no trace, or the pot cracking during drying because of differences in the moisture between the layers.

For more intricate designs, it is possible to remove some of an added layer with a very sharp knife (the disposable-blade type) or with a hypodermic needle (they are extremely sharp and come in different sizes).

It helps a lot in distinguishing the various layers of a white-on-white pot if an addition of organic colouring compounds (food colouring) is mixed with the slip for the second/third layer.

Spray-casting in combination with the multiple casting technique

1. An outer layer of slip is sprayed into the mould using a spray gun.
2. The slip is allowed to dry and areas are cut out whilst cast is still in the mould.
3. Another layer of slip is cast into this and allowed to dry.
4. The piece is removed from the mould and heated up using a gas torch.
5. Once hardened up, more areas are cut out from the *exterior* of the cast to reveal the layer underneath.

1.

2.

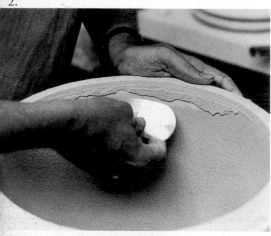

3.

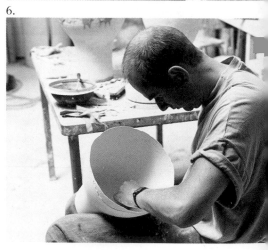

4.

5.

6.

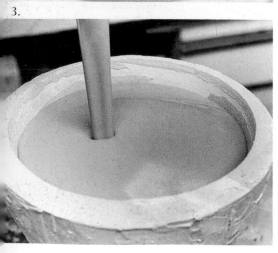

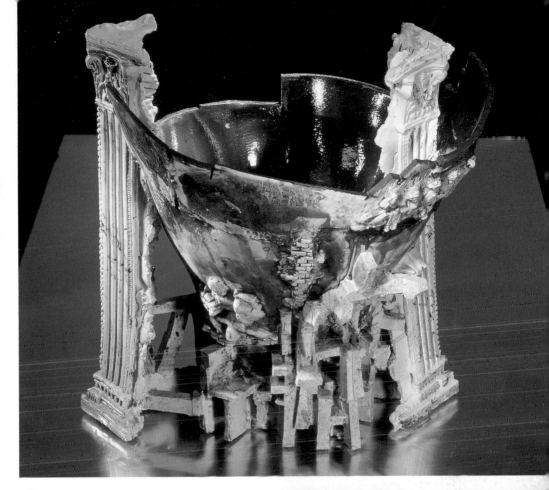

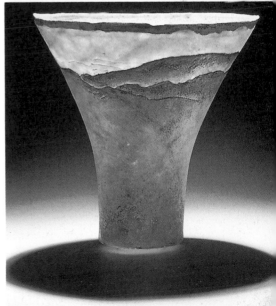

Above
'78th reconstruction of the Holy Grail' by
Jeroen Bechtold (Holland), 1992, h. 48 cm.
Porcelain using assembling techniques,
glazed and platinum lustre. *Photograph by
Rene Gerritsen.*

Right
Work by Jeroen Bechtold (Holland), 1993, h.
26 cm, porcelain using the spray-casting and
cutting technique. *Photograph by Rene
Gerritsen.*

Left
Sequence of spray-casting and multiple
casting technique. *Photograph by Anita de
Jong.*

6. The piece is soft biscuited, after which the inside is sanded down.

Angela Mellor

Angela Mellor is an English ceramicist now based in Australia and Indonesia who works mainly in bone china. Starting from a clay original (which is normally slab built) she makes three or four-piece moulds, depending on the form. She exploits the warping nature of bone china by *not* using setters thus allowing the pieces to move voluntarily in the firing. Occasionally, she works on the form in the damp stage, after early removal from the mould, by gently encouraging rim distortion. Further distortion occurs during the firing depending on where the pieces are placed in the kiln i.e. in 'hot spots'. She

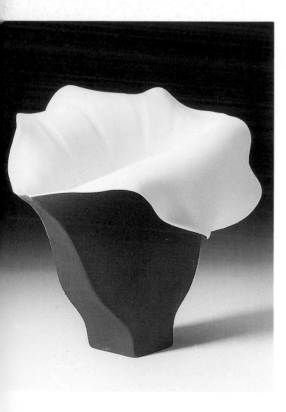

fires to 1240°C with a ½ hour soak prior to which the pieces have been sprayed with under-glaze colour – no glaze is used. To prevent the pulling in or closing up of the shape during firing, the pieces are filled with alumina. This is possible as the shapes are tapered outwards from the base and so, as the piece shrinks, the alumina will move upwards and therefore contraction of the form around the alumina is not a problem.

Carol McNicoll

Carol is a London-based ceramicist who makes one-off and production pieces. She uses casting in a spontaneous manner combining casting and assembling / hand-building techniques.

To create the models she uses a combination of materials which will make the desired shape – usually, they are a collage held together with clay. She views the models as expendable for they are normally destroyed when the mould is taken apart. Work is quite often done directly on to the mould, either to correct mistakes or to add decoration.

She works with a high-firing earthenware using a clay from Scarva Pottery supplies which she mixes up herself into a slip and alters it to suit her particular needs by adding 1 lb of Molochite to 1 gallon of slip. This makes for easier hand-building. She prefers to slightly under-deflocculate the slip which facilitates removal of the more complex shapes from the moulds.

All the work is decorated with coloured slips and occasionally with underglaze colours, on glaze and

Bone china form with sprayed underglaze colour by Angela Mellor, h. 19 cm.
Photograph by James Austin.

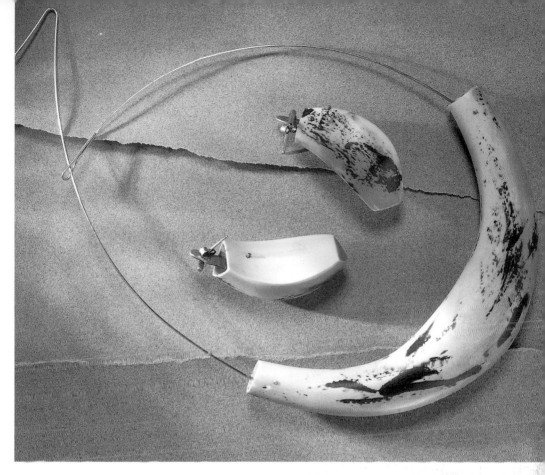

engobes. The slips are made from underglaze colour or universal stain mixed with casting slip and are applied to the greenware when bone dry.

The pieces are fired to 1180°C so that the clay is almost vitrified after which a glaze is applied and fired to 1060°C. (See page 106 for illustration.)

Penkridge Ceramics

Nicky Smart and Lorraine Taylor have formed a partnership based in the West Midlands where they produce realistic-looking ceramic fruit and vegetables. The models are, in fact, real fruit which normally require a two-piece mould and which include a third plug section to cast over the pouring hole (see Chapter 5).

They are cast using a semi-porcelain

Bone china necklace and earrings by Alison Small. *Photograph by Allan Mower*.

clay or a high-fired earthenware. Items such as cauliflowers, pineapples and artichokes are moulded in sections after which the cast pieces are assembled using casting slip and fired to 1140°C.

The couple make their own glazes using basic lead-free industrial base glazes to which matting agents and body stains are added. The coloured glazes are sprayed on each piece in layers, in some cases as many as six, to create the depth of surface needed. Finally, the blemishes of the fruit are added by hand using a glaze on top of the final glaze before firing to 1020°C. The stalks in the apples and pears are made from either real twigs or carved and stained cane.

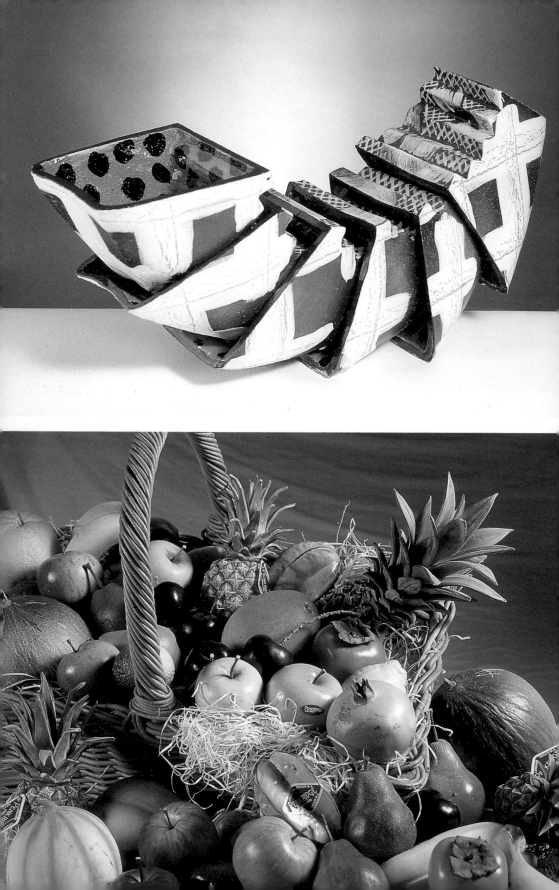

Left
'Double Vase' by Carol McNicoll 1989, L. 55 cm × h. 25 cm. Cast and assembled earthenware, decorated with coloured slips and underglaze colour.

Left, below
Ceramic fruit and vegetables by Penkridge Ceramics.

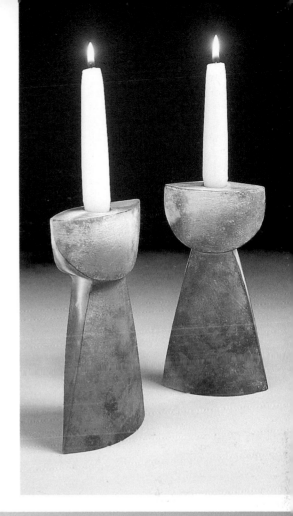

Right
Pair of candlesticks by Tessa Wolfe-Murray, h. 18 cm. Cast in red earthenware and smoke-fired.

Below
'Café Boule' by Ulrike Weiss (France), 1992. Cast in earthenware. *Photograph by Despatin Gobeli.*

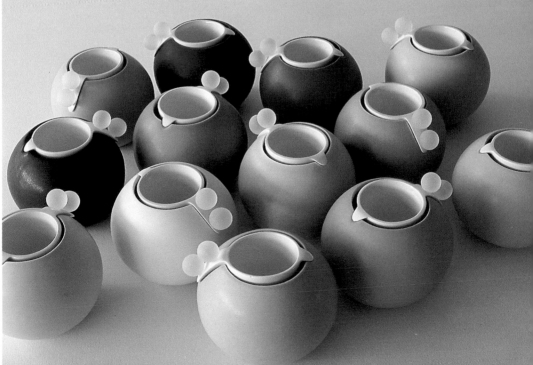

Tessa Wolfe-Murray

Tessa makes her models from clay and moulds them in two or three pieces, depending on the forms. They are cast through the base so they can serve as a vase when inverted, using a red earthenware slip. The interior is raw-glazed using a Potterycrafts transparent glaze P 2018. Prior to firing, coloured slips are sprayed onto the greenware and they are fired to 1060°C in an electric kiln. The pieces are finally smoke-fired in an open sawdust kiln using pure sawdust and white spirit.

Alison Small

Alison is a Bristol-based ceramicist using mouldmaking and slipcasting on a small scale to produce bone china jewellery. The models are made from carving small blocks of plaster producing either one 'master', or original shape, or two mirror-image pieces. They are generally simple two-piece moulds. She uses stained slips either with stoneware glazes or body stains which will withstand the high biscuit temperature. The majority of the decoration is applied by painting stained slip into the inside of the mould and layers of different colours are built up so that the surface becomes one solid body.

After the desired effect has been achieved the mould is closed and the main body of the slip is poured into the mould for approximately 30–60 seconds. The casting time varies depending on the use of the jewellery. The excess is then poured out so as not to make the pieces too heavy. The main body of the slip combines with the painted decoration to produce a type of reverse inlay decoration.

Variations of applying coloured slips directly onto the plaster mould prior to casting are as follows:

– dragging a loaded brush slowly across the plaster to produce a stippled bark effect. By applying up to three differing colours creates a three-dimensional effect.
– a single coloured, undecorated slip that will be given surface treatment using lustres.
– using a thin, watered slip initially, allowing this to dry before applying a thicker layer of slip. After a soft bisque firing, the surface is rubbed away to disclose areas of thicker slip. Lines are then sawn into the body at irregular intervals. Following the high firing, the body is polished, enamels are inlaid into the incised lines and fired to 990°C–1000°C.

As no glaze is used, Alison has introduced a soft-firing of 1000°C so that a smooth polished surface can easily be achieved. She uses a variety of grades of wet and dry paper starting with 240 and finishing with a 800 grade. As well as obtaining an ultra-smooth surface, the edges can be sharpened up to achieve crisp and distinctive detail. It is at this stage that holes are drilled for 'finding' attachments and any inlaid details are inscribed.

The concave pieces are supported in the kiln to prevent warping.

They are fired to between 1220°C–1230°C and soaked for two hours to ensure vitrification. The translucency, although apparent, is not so crucial as the forms are small and enclosed.

After the high bisque firing, the china surface is polished in three stages:

1. Hand polishing using 'Tri-m-ite' Frecut paper grade P 180.
2. Hand polishing but using grade P 240 paper.
3. Finally, polishing wax on a polishing machine using a cloth wheel.

If the pieces are to be lustred then a further firing of 990°C–1000°C is required.

Ulrike Weiss

Ulrike is a German ceramicist working in Paris. Her approach is one of contemporary design using the casting technique to produce functional objects. She uses plaster prototypes which either have been turned on a whirler or carved directly from a block of plaster. After moulding, she casts with a dolomite earthenware slip fired to 1050°C. The dolomite gives the slip a very white base and limits the shrinkage properties. The pieces are glazed using a combination of prepared glaze stains and a matt base glaze.

Patrick Maunoury

Patrick is a French ceramicist working in Paris using a contemporary utilitarian approach combining both design and function. The work is cast in white earthenware and fired to 1050°C. The prototypes are in plaster which have been turned and hand carved, if necessary. One or more moulds are made from the same model to accelerate production and two casts can be achieved per mould per day.

After the biscuit firing, the pieces are glazed by spraying a matt-stained glaze and firing to 980°C. If further decoration is required then lustres or silkscreen transfers are added necessitating a third firing to 700°C. Alternatively, some additions can be applied after the bisque firing but prior to the glaze firing. For example, with the egg cup, the object was moulded in four pieces and each glazed separately. The wave and the flag were then stuck on using glaze which fused them together during the firing.

Anthony Theakston

Anthony Theakston is a Lincolnshire ceramicist who is currently making a series of jugs in the form of birds. The models are hand-carved from a block of plaster (Herculite) using a strong dense mix. A 'true' block of plaster is made taking into account the widest point of the jug. The bird is drawn onto the

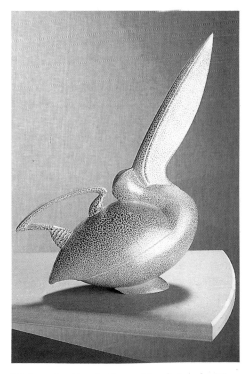

'Pelican Jug' by Anthony Theakston, h. 35 cm. Cast in earthenware.

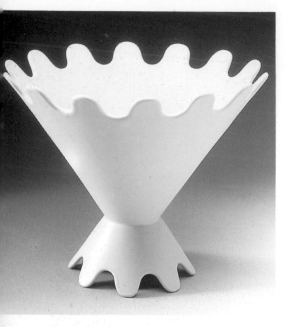

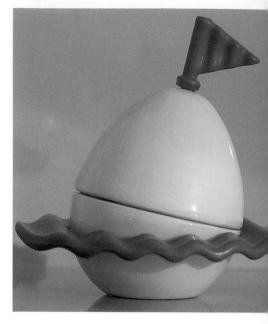

Earthenware vase by Patrick Maunoury (France), h. 40 cm, 1989.

'Egg cup' by Patrick Maunoury (France), 1991. Cast in earthenware.

plaster and a bandsaw cuts out the profile. The centre line is then traced onto the block running right around the body. This is essential as symmetry is paramount.

Carving and shaping the bird is carried out working from the centre line to the sides of the form until the desired shape is achieved. An assortment of tools is used including a surform, assorted riflers, scalpels and finally wet and dry paper for polishing the plaster. Anthony uses a process of 'running on' or casting additions of plaster onto the already carved body to achieve the feet and handles, prior to moulding.

The models are then moulded in three separate sections – the body, the handle and the foot. Usually each of these sections require two-piece moulds. The moulds are cast for approximately 20 minutes. Once they hardened up, they are removed from the moulds and the feet and handles are assembled with the body using casting slip. Whilst still leatherhard, the casts are sponged and the lines redefined before leaving the object to dry.

After a biscuit firing of 1140°C, the forms are glazed inside and out using an imitation salt-glaze effect which is achieved by firing up to as many as three times to approximately 1170°–1200°C. By high firing the coloured glaze and applying varying glaze thicknesses, a crawling effect is achieved.

Caroline Harvie

Caroline is a Scottish-based ceramicist working in bone china.

The models are made from plaster which has been turned on a horizontal turning lathe. If a multi-piece mould is necessary, the models are usually

designed so that the seam line runs horizontally on the widest point or edge rather than vertically to avoid the apparent marks after firing. The widest point is then easily marked on whilst the model is still in position on the lathe.

With forms that require a simple drop-out mould, Caroline has devised an unusual method of cottling using cheap plastic flower pots from which the bases have been cut off. This, she says, allows for neat exteriors and provides a small ridge which facilitates handling.

1. A tapered plaster bat is made by pouring into the flower pot and then removing. A centre point is marked on this. This is flattened off on a kiln shelf which is reserved for this purpose.
2. The spare and model are placed on the centre of the bat and all the plaster elements are soaped up and the flower pot is replaced fitting perfectly.
3. Plaster is poured in through the base of the flower pot to make the mould. The models drop out easily from the moulds approximately 23–24 minutes after pouring. The cottle is removed 30 minutes later.

Caroline mixes up her own casting slip using plastic bone china clay plus dispex and water. The recipe for raw materials is:

50% Bone ash
25% Cornish stone
20% China clay
5% Ball clay

The mixture is sieved through a 200s mesh sieve and the pint weight of the slip is 37 fl. oz.

Caroline usually removes the casts

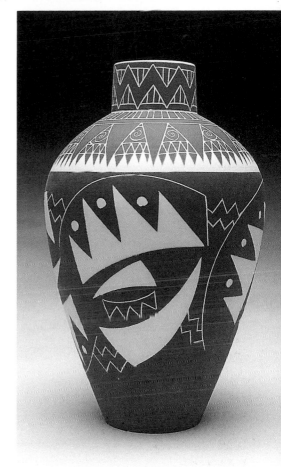

Bone china vase by Caroline Harvie (Scotland). *Photograph by John P. Bisset.*

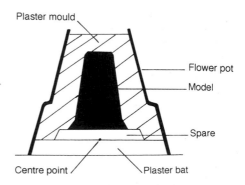

Plaster mould

Flower pot

Model

Spare

Centre point

Plaster bat

'Flower pot' mould. *Courtesy of Caroline Harvie.*

from the moulds after 3–4 hours. However, she does speed up the process by using a microwave for small moulds which contain simple shapes and which do not have any contraction problems. She has also found that 'microwaving' the moulds helps to dry them quickly and so prolong the mould-life.

Setters, in the form of a shallow dome shape, are cast at the same time as the pieces and are placed on the top of the vases during drying and the high biscuit firing.

The pieces are decorated in the raw state using a black stained bone china slip:

> *Recipe*: 1 pint of casting slip
> 10% of black body stain
> 50 parts water by volume
> A drop of calcium chloride
> (clay suspender)

The resist decoration is achieved by using latex which is stained with food colouring and paper resists. She uses resists cut from a phone book with a scalpel. This gives 20–30 identical positive and negative stencils. Sgraffito decoration is applied for the thin white lines on the body and on the white pieces the thin black lines are inlaid.

The pieces are high biscuited in an electric kiln to 1265°C and soaked for 1 hour. It is then cooled slowly to 100°C when the bungs are removed. For those pieces left unglazed, they are polished using wet and dry paper.

Glazing is carried out using a ready-prepared industrial transparent low-solubility glaze with a drop of calcium chloride and dispex, plus food colouring which burns away during the firing. The food colouring assists with even application whilst spraying, as the glaze can be seen clearly particularly on the white pieces. The insides are poured and the outsides are sprayed (see Chapter 7). If any underglaze decoration is to be applied, this is painted on and the glaze sprayed over the top. The pieces are then fired to 1060°C with a 1 hour soak. Finally, if applicable, platinum lustre is painted on and fired to 750°C.

Angela Verdon

Angela's earlier cast work was in bone china but, as she found the scale too limiting, so she now uses Limoges porcelain. For her bone china pieces, simple models were turned on a plaster lathe. These required drop-out moulds and were cast for a matter of seconds to obtain very thin pieces. They were not touched before being placed in the kiln and fired to 950°C for a soft biscuit. If further distortion was required, they were pushed and encouraged in the damp stage. If any decoration work was to be executed, drilling and piercing with dentist drills or hand diamond files were

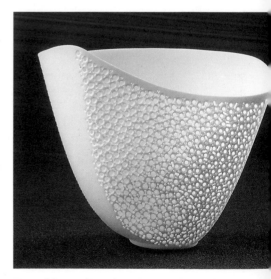

Pierced bone china form by Angela Verdon. *Photograph by John Cole.*

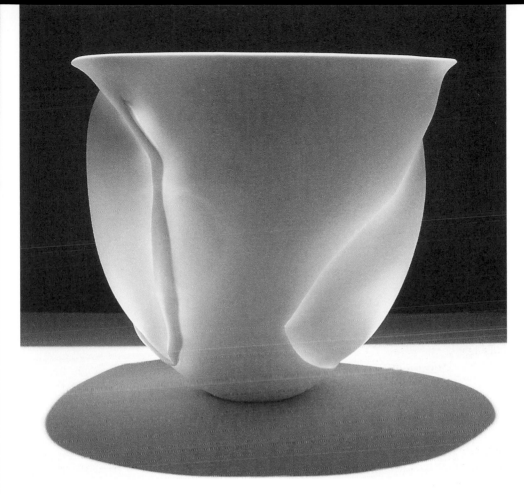

Carved porcelain form by Angela Verdon.

used at this stage and the work subscquently sanded with diamond pads and wet and dry paper.

The pieces were fired to 1220°C, soaked for 1 hour and then burnished to a high egg-shell finish. She preferred to allow the taller pieces to move voluntarily in the firing, so she left them free-standing in the kiln. The bowls were fired upside down on their rims sitting on setters.

Her more recent pieces are in porcelain using a Limoges body which are cast very thickly and drawn on. Following the drawn lines they are carved away leaving raised relief areas graduating to very thin areas which accentuate the differing degrees of translucency.

Linda Gunn-Russell

Linda's earlier work which was made between 1975–1978 was cast in white earthenware. The models were carved from blocks of plaster from which three- or four-piece moulds were made. For example, the pepper teapot required a three-piece mould which was seamed horizontally and special air holes were included on the top to allow the slip to rise (see diagram).

The biscuit firing was to 1180°C, after which a green underglaze was sprayed on before a transparent glaze was applied and the piece fired to between 1060°–1080°C.

113

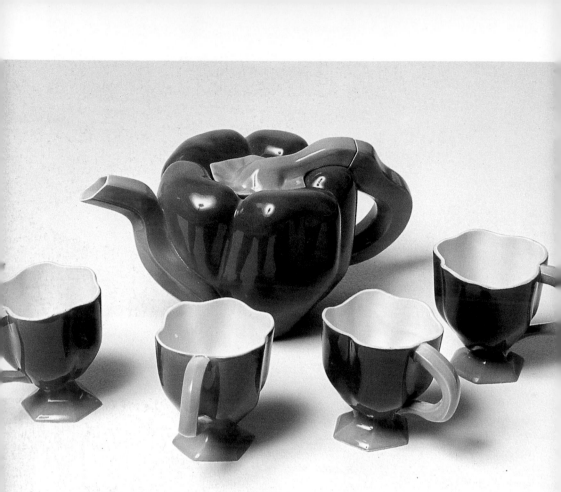

Pepper teaset by Linda Gunn-Russell, 1975, h. 20 cm.

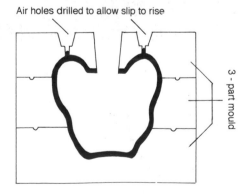

Air holes drilled to allow slip to rise

3 - part mould

Horizontally-seamed mould with air holes.
Courtesy of Linda Gunn-Russell.

François Ruegg

François Ruegg is a Swiss ceramicist working in porcelain and bone china who has developed and perfected a method for maintaining completely flat sheets of china and porcelain. The porcelain plaques are made by using a slab-roller. They are sometimes cut and folded in the green state or, cut *after* the high firing using a diamond-cutting disk.

The porcelain is fired to 1280°C in a gas kiln and the pieces are supported upside down on another porcelain plaque which is consequently discarded after the firing.

The bowls are cast in bone china. The

Above
Porcelain plaque by François Ruegg
(Switzerland), 1993. Cut and folded in green
state.

Below
Bone china bowl with off-centre rim and
plaque by François Ruegg (Switzerland),
1991.

model is made by turning plaster on a
horizontal turning lathe from which a
simple drop-out mould is made. To
obtain the off-centre rim, an inside-fitting
spare is displaced, prior to running the
reservoir ring during moulding (see
diagram). After casting they are fired to
1230°C in an electric kiln. Afterwards
the pieces are polished and the black line
of enamel decoration is fired to 800°C.
The plaque underneath is bone china
which has been engraved and polished.

Diagram showing displacement of spare.

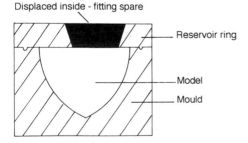

Model, mould and spare

Cast after draining and spare cut off.

Alison Gautry

Alison has developed a technique for producing ultra-thin porcelain pieces by spinning the mould whilst casting. It is, in fact, a technique which combines 'jiggering' and casting. The initial model is turned on a whirler, from which a mould is made. The mould fits into a jigger-head and, whilst it is revolving, an egg cup full of slip is added to the mould. The centrifugal force moves the slip rapidly up the mould and slightly over the edge of the mould. This takes approximately 4–5 seconds. The excess is cut off and is left to release in its own time. The bowl is then placed on a setter and left to dry overnight before being placed in the kiln where it is fired to 1280°C in 8 hours.

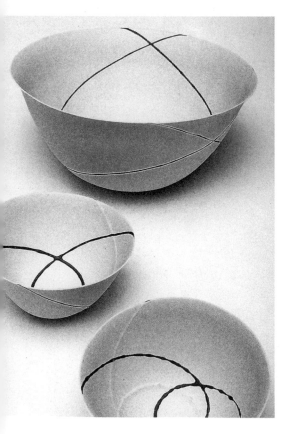

Ann Shepley

Working on a miniature scale, Ann makes slipcast doll's house replicas for the collectors market. She uses traditional industrial techniques yet they are scaled down to 1 in 12 which requires a great deal of precision and dexterity. For example, in the illustration, the dimensions of the bath are $5\frac{1}{2}$ (high) × $1\frac{3}{4}$ (long) × $2\frac{1}{2}$ inches wide ($14 \times 4.5 \times 6.5$ cm).

Rather than producing a free-standing object prior to moulding, the models are worked in reverse. For example, the inside of the bath is made first as a hump mould over which slip is poured. This gives an even thickness and is referred to as 'core casting'. (It is similar to the floating technique described in Chapter 5.) Further modelling is done in clay on top of this, prior to making the subsequent parts of the mould. Some of the items require quite complex moulding, for example, the toilet necessitates an eight- piece mould.

After moulding, they are cast in white earthenware and raw glazed after which they are once-fired to 1140°C. Any further decoration is added by means of a silkscreen transfer. Ann prefers to raw glaze as she says the 'fit' is better which is particularly important with work of this scale as too much glaze 'pick-up' will obliterate the relief decoration and there can be a tendency to over-glaze on thin, small casts. Any 'moulding' decoration is done by using the clay sledging technique, for example, on the wash basin. The pedestal of this item was hollow cast.

Porcelain 'spun' bowls by Alison Gautry, h. 7 cm.

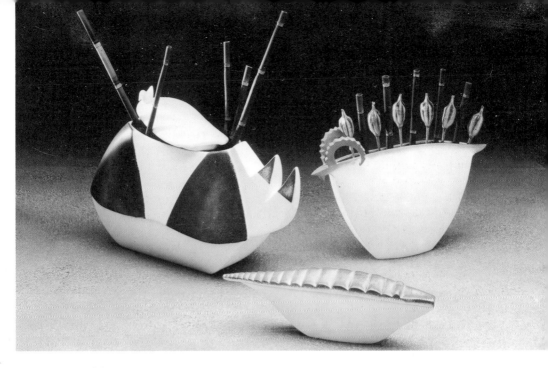

Range of porcelain animals designed by
Thalia Reventlow (France) and produced by
Bernardaud, Limoges, France. *Photograph by
Dominique Cohas, Paris.*

Below
Miniature Victorian bathroom by Ann
Shepley, scaled down to 1 in 12 cast in
earthenware and raw-glazed.

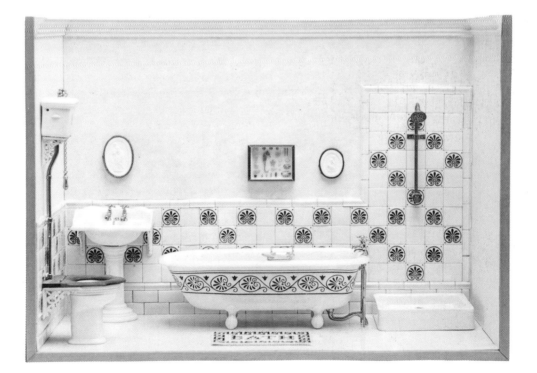

Thalia Reventlow

Thalia is a Danish ceramicist working in France who is among one of the few contemporary ceramicists who have managed to break through the strong classical tradition of designing for the ceramic industry in France. She was commissioned to design a range of items which were to be industrially-produced by Bernardaud, one of the main porcelain manufacturers in Limoges. Being originally a hand-builder, her brief was to design a range of vases and lidded containers by adapting her own way of working and to simulate the objects in plaster. She therefore supplied first the model prior to the moulding and subsequent blocking and casing stages which were required for mass production.

The pieces are slipcast using Limoges porcelain and fired to approximately 1400°C.

Sasha Wardell

My work is made solely in bone china ranging from functional to decorative pieces. The models are made from plaster using a horizontal turning lathe to give a curved profile. After turning they are divided up to introduce twists or facets and carved by hand using a variety of tools – surform, hacksaw blades, rifflers and polished with wet and dry paper. For flatter models, plaster is poured onto a sheet of glass and sandwiched between it and another one (see Chapter 3). Hand carving is carried out afterwards.

The majority of shapes are made so that a simple drop-out mould will suffice. However, in cases where a more complex form necessitates a multi-part mould, the seam lines are disguised along the shoulders or edges.

The casting slip used is Valentine's ready-prepared bone china slip which still requires sieving through a 60s sieve

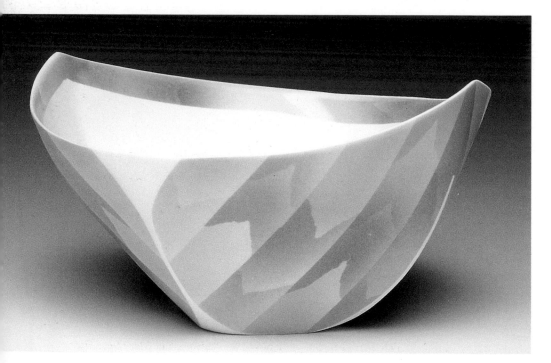

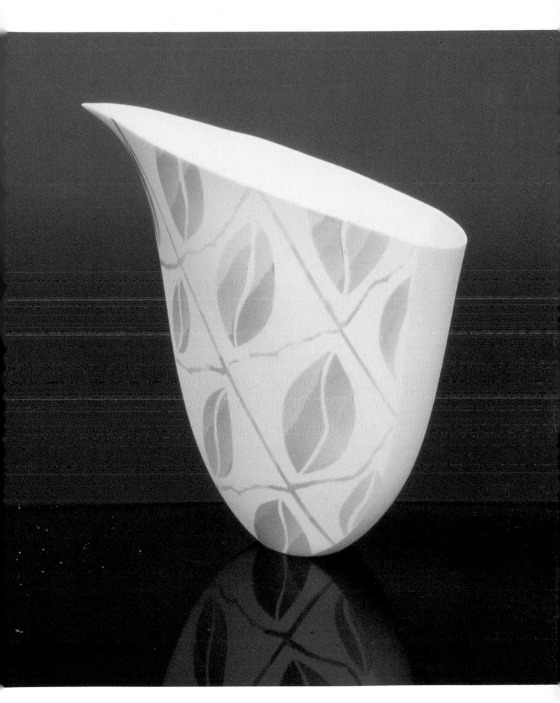

Above
Painted vase by Sasha Wardell, 1996, h. 17 cm. *Photograph by Theo Lode de Leede.*

Left
'Boat bowl' by Sasha Wardell, h. 10 cm. Cast in bone china. *Photograph by Mark Lawrence.*

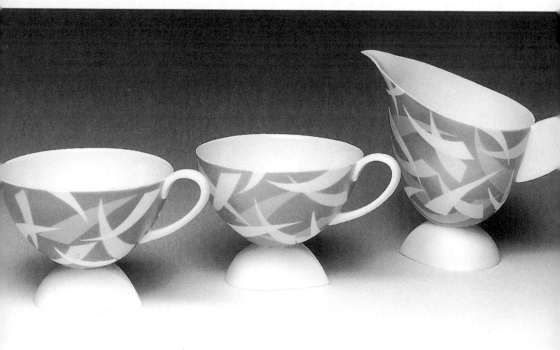

Above
Pair of distorted bone china bowls with wax resist decoration by Sasha Wardell, 1994, h. 5 cm. *Photograph by Mark Lawrence.*

Below
Pair of based cups and jug by Sasha Wardell, 1994. Cast in bone china. *Photograph by Mark Lawrence.*

and adjusting slightly with approximately 1–2 drops of Dispex per gallon to aid fluidity.

Each piece is cast for approximately 2–5 minutes depending on the size of the object and thickness required. Once the spares have been cut off, the casts are left in the moulds overnight to harden up and are then removed the next day. The setters are cast at the same time and are dried together with the pieces.

When the casts are bone dry, the edges are softened with a sponge prior to the soft firing of 1000°C. After this, fettling takes place using wet and dry paper (dry) grade 400 and the excess dust which is created is sponged away.

The pieces are fired to 1260°C with a $1\frac{1}{4}$ hour soak (see Chapter 7). Pieces which require setting are normally fired upside down on a setter. Tall narrow-based forms are packed with alumina around the weak point to act as support during the firing and some forms are allowed to warp of their own accord.

The decoration is applied after the high biscuit, onto the vitrified ware, using masking tape and an airbrush. A series of intricate masks are built up, super-imposing one layer over another, and removing them in reverse order – spraying a colour and removing a piece of tape until the whole piece is unmasked. The colours are a mixture of $\frac{1}{3}$ body stain or underglaze and $\frac{2}{3}$ glaze using a Potterycrafts transparent low earthenware glaze.

Due to the fine spray achieved by using an airbrush, the over-sprayed colours do not obliterate the shapes or colours underneath but gradually alter and build up densities of colour.

The pieces are finally fired to 1020°C to achieve a satin-matt effect. By slightly under firing the transparent glaze, it is not fully matured and so becomes less shiny – a higher temperature will increase the gloss. After firing all the pieces are polished using fine grade wet and dry paper, using it wet, to obtain a satin-matt egg-shell finish.

Appendix

Conversion Factors

To convert from	into	multiply by
oz	gm	28.35
gm	oz	0.0353
lb	kg	0.4536
kg	lb	2.2046
cwts	kg	50.803
kg	cwts	0.0196
tons	kg	1016.2
tons	tonnes	1.016
oz/pint	gm/cm^3	0.05
oz/yd^2	gm/m^2	33.9
in^2	cm^2	6.4516
in	cm	2.54
cm	in	0.3937
feet	metres	0.3048
ft^3	litres	28.317
ft^3	in^3	1728

Volume

1 m^3	= 1000 litres	= 35.31 ft^3
1 litre	= 1000 cc	= 0.3531 ft^3
1 cc	= 1000 mm^3	
1 yard3	= 27 ft^3	= 0.76 m^3
1 Imp. gallon	= 4 quarts	
	= 8 pints	
	= 4.56 litres	
	= 1.205 US gallons	
1 pint	= 20 fluid oz	
	= 0.5683 litres = 568 cc	
1 litre	= 0.2199 gallons	
	= 1.7598 pints	
	= 35.196 fluid oz	
	= 0.2642 US gallons	
	= 2.1132 US pints	
	= 1000 cc	
	= 61.025 in^3	
	= 0.0353 ft^3	
1 ft^3	= 28.317 litres = 0.028 m^3	
	= 6.237 gallons	
	= 7.481 US gallons	

Dry Content of one pint of clay slip at various pint weights

Slip Weight (ozs/pint)	Dry Content (ozs)	Slip Weight (ozs/pint)	Dry Content (ozs)
20	0.00	30	16.67
21	1.67	31	18.33
22	3.33	32	20.00
23	5.00	33	21.67
24	6.67	34	23.33
25	8.33	35	25.00
26	10.00	36	26.67
27	11.67	37	28.33
28	13.33	38	30.00
29	15.00	39	31.67

Ounces		Grams		Pints		Litres
1	=	28.4		0.5	=	0.3
2		56.7		1.0		0.6
3		85.0		1.5		0.9
4		113.0		2.0		1.1
5		141.7		2.5		1.4
6		170.1		3.0		1.7
7		198.4		4.0		2.3
8		226.8		5.0		2.8
9		255.1		6.0		3.4
10		283.5		7.0		4.0
11		311.8		8.0		4.6
12		340.2		9.0		5.2
16		453.6		10.0		5.7

Ounces per pint		Grams per litre
10.0	=	498
20.0		996
26.0		1295
27.0		1345
28.0		1395
29.0		1445
30.0		1494
32.0		1594
33.0		1643
34.0		1693
35.0		1743
36.0		1793
37.0		1843

Temperature Conversion

To convert °C into °F
 multiply by 9 then divide by 5 and
 add 32.
To convert °F into °C
 deduct 32 and multiply by 5 then divide
 by 9.

Glossary of terms

Alabaster A hydrated calcium sulphate ($Ca\ SO_4\ 2H_2O$). The pure crystalline form of gypsum.

Alumina An oxide of aluminium (Al_2O_3). Supplied as calcined alumina or alumina hydrate.

Bat A term used in mouldmaking for a board of wood or sheet of plaster on which the model is supported. Can also be applied to the retaining walls of a mould made in plaster.

Bitting Pre-formed piece of slip used in handle moulding to make solid handles whilst casting.

Block See Chapter Five.

Blunging Method of mixing clay and water mechanically to make casting slip.

Calcine To heat a substance in order to drive off the water content.

Case See Chapter Five.

Casting Forming pottery by pouring slip into a porous mould (see slipcasting).

Cottle Sheets of linoleum, or plastic, used as retaining walls for plaster usually on round forms.

Deflocculation Means retaining a *high density* but *fluid* slip by means of adding an electrolyte (deflocculant). These aid the dispersion of particles in the slip leading to increased fluidity requiring less water.

Dottle A type of long sponge on a stick, usually synthetic, used for cleaning the interiors and rims of tall forms.

Double cast Method of casting where the mould forms both the inside and the outside of the piece. This results in two cast thicknesses touching and forming a solid cast.

Electrolyte 'A compound which, when dissolved in water partially *dissociates* into *ions* (electrically charged atoms and molecules).' Courtesy of A.D. Dodd's *Dictionary of Ceramics*, London, Newnes-Butterworth, 1967. Deflocculants are termed electrolytes when used in conjunction with casting slips.

Fettling Cleaning up seam lines on greenware with a knife or sponge prior to firing.

Flatware General term used in mouldmaking to describe plates, dishes, saucers etc.

Greenware Unfired clay ware.

Grid Pre-formed piece of slip with holes pierced in it. Used as a 'strainer' at the base of a spout.

Gypsum Partially dehydrated mineral from which plaster is derived.

Holloware General term used in mouldmaking to describe teapots, cups, jugs etc.

Jiggering and jolleying A technique used to form shapes by means of a profiled tool at a fixed distance from a rotating surface of a plaster mould.

Lathe A machine used for turning plaster models horizontally.

Livering Condition of a slip when it appears thick and jelly-like. (See Chapter Six.)

Natch Means of ensuring positve location and exact registration of mould parts. Usually small round indentations and projections.

Pinholing Small air holes present just beneath the surface of a slip. (See Chapter Six.)

Plaster A soft porous stone resulting from the combination of partially dehyrated gypsum and water.

Plugging Mouldmaking technique used to give impression of a *solid* shape. (See Chapter Five.)

Porosity The amount of 'pore' space in dried plaster, or in a ceramic material, which may consist of both open and sealed channels.

Saggar Container made from a coarse refractory clay in which pots are placed to protect them from flames during a gas firing. They are also used for supporting certain objects whilst being filled with alumina.

Setter An extra item used to reduce warping of the rims of pieces of high-firing clays. Either cast and fired at the same time as the piece or, a pre-fired refractory ring used as support during the firing.

Slip Suspension of clay in water.

Soda ash/Sodium carbonate (Na$_2$Co$_3$) A common deflocculant used in the manufacture of some casting slips.

Sodium silicate Water glass (Na$_2$ SiO$_3$). A common deflocculant.

Spare The extra or 'spare' space at the top of a mould which acts as a pouring hole for the slip once the mould has been made. It also provides storage for extra slip as the level drops during casting and allows for topping up if necessary.

Specific gravity A number achieved by dividing the weight of a material by the weight of an equal volume of water.

Thixotropy The ability of certain clay suspensions to thicken up on standing. A characteristic of partially or over-flocculated slips.

Turning The process of paring down plaster to achieve a form whilst the plaster rotates.

Undercut Area on a model which prevents removal or withdrawal of the mould.

Viscosity The resistance to flow offered by a liquid. The opposite of fluidity.

Vitrification The progressive fusion of a material or body during the firing process.

Whirler Machine with a plaster turntable which rotates, used mainly to make flatware and simple drop-out moulds. Turning is carried out *vertically*.

Wreathing Small uneven ridges or waves on the drained inside surface of a cast body. (See Chapter Six.)

Bibliography

Books

Chaney and Skee, *Plaster Mold and Model Making*, Prentice Hall Press, 1986.

Cowley, David, *Moulded and Slip Cast Pottery and Ceramics*, B.T. Batsford, 1978.

Fournier, Robert, *Illustrated Dictionary of Practical Pottery*, A & C Black, Chilton Book Company, 1992.

French, Neal, *Industrial Ceramics: Tableware*, Oxford University Press, 1972.

Frith, Donald E., *Mold Making for Ceramics*, A and C Black, Chilton Book Company, 1992.

Hamilton, David, *Pottery and Ceramics*, Thames and Hudson 1974.

Leach, Bernard, *A Potter's Book*, Faber and Faber, 1940.

Whyman, Caroline, *Porcelain*, B.T. Batsford, 1994.

Journals

Dodd, A.E., 'Notes on the Early Use of Plaster and Slip Casting', *Journal of the British Ceramic Society* (vol vi. 1969).

Shaw, Simeon, *History of the Staffordshire Potteries*, David and Charles, 1970.

Magazines

Ceramics Monthly, PO Box 12788, Columbus, OH 43212–99 33, USA

Ceramic Review, 21, Carnaby Street, London WIV IPH.

La Revue de la Ceramique et du Verre, 61, rue Marconi, 62880 Vendin-le-Vieil, France.

Suppliers

UK

Potterycrafts Ltd., Campbell Road, Stoke on Trent, ST4 4 E5, UK.
Tel: (01782) 745000

Potclays Ltd., Brickkiln Lane, Etruria, Stoke on Trent, ST4 7BP, UK.
Tel: (01782) 219816

Bath Potters' Supplies, 2 Dorset Close, Bath, Avon, BA 2 3RF UK.
Tel: (01225) 337046

Valentine's Clay Products, The Sliphouse, Birches Head Road, Hanley, Stoke on Trent, UK.
Tel: (01782) 271200

Reward – Clayglaze Ltd., Units a and b., Brook House Industrial Estate, Cheadle, Stoke on Trent, ST10 1PW, UK.
Tel: (01538) 750052

British Gypsum, Jericho Works, Bowbridge Road, Newark, Notts.
Tel: (01636) 703351

Alec Tiranti, 27 Warren Street, London W1P 5DG
Tel: 0171-636 8565

US

Axner Pottery Supply
P.O. Box 1484
Oviedo, Florida 32765
Tel: 800-843-7057

Davens
198 Murray Drive
Atlanta, Ga 30341
Tel: 800-695-4805

Laguna Clay Company
14400 Lomitas Avenue
City of Industry, CA 91746
Tel: 800-452-4862

Index

Aylieff, Felicity 26

ball clay 86, 88, 98
bats, moulding 13, 21, 30–31, 54–5
bench whirler 19
Bettignies, Monsieur 9
Billington, Dora 86
bone china 26–8, 61, 73, 75–8, 82, 85–100, 104, 110–12, 114, 115, 118–21
Bottger, Johann Friedrich 85
Bow 86
'boxed' cups 92, 98
Boyes, Alma 26
British Gypsum 12–14
Brongniart, Alexandre 9
 formulae 80–82

Chaney and Skee 59
Chelsea 86
chuck 34–8
cottle 16–17, 20–21, 30–31, 34, 39, 50

Derby 86
double casting 67–8

earthenware 61, 71, 73, 76, 78
Elers brothers 9, 10

fettling 77, 78, 83
Frith, Donald 28
flatware 19
floating 67–8
Frye, Thomas 86

Gautry, Alison 116
Gunn-Russell, Linda 113–14
gypsum 11

handles 40–42, 63, 77–9
Harvie, Caroline 99, 110–12
holloware 8, 92

jigger and jolley 8, 91

Leach, Bernard 6
lids 61–4
Limehouse 86
Limoges 112, 118

Maunoury, Patrick 109, 110
McNicoll, Carol 104, 106
Medici, Francesco Mario de 86
Meissen 10, 85
Mellor, Angela 104
Ming Dynasty 85
models 27, 29–30, 52
moulds and moulding 59, 79
 block and case 13, 59–60, 79
 drop-out 44, 49–53, 59
 drying and storage of 17, 52–3
 'locking' bottom 57
 multi-part 44, 54–7
 'split' 45, 58–9, 79

natches 23, 37, 40, 43, 44, 51, 56
Nympenburg 10

Ohain, Pabst von 85

Penkridge Ceramics 67, 105–6
plaster of Paris 7–17, 33
plaster-water ratios 11, 14, 15
plugging 70, 105
Pomona 86
porcelain 61, 73, 75, 77, 78, 85–7, 97, 98–9, 116

refractory ring 91
reservoir ring 46–52, 54, 59–60, 115
Reventlow, Thalia 117–18
riffler 22, 42, 43, 54, 61
Ruegg, François 93, 114–15

salt bloom 79
salt glaze 10
sanitary ware 13
Scarva Pottery 104
seamlines 61, 67, 87, 89
semi-porcelain 24, 25, 27, 28, 73
Sèvres 9, 10
Shepley, Ann 69, 116–17
sledging 22, 31–4, 116
slip 7, 46–7, 80, 83
 casting 73, 74, 75, 82, 83
 deflocculated 9, 71
 pinholes 74, 82, 83
 preparation of 74
 recipes 73
 shrinkage guides 28
 troubleshooter chart 82–3
 water slips 9, 77
Small, Alison 105, 108–9
Smart, Nicky (see Penkridge Ceramics)
soaping 21, 28–9, 50, 51, 52, 54
spacer 35, 50
spares 23, 46–9, 54–5, 57, 115
spindle 34–5, 38
Spode, Josiah 86
spouts 43–4, 64–6, 77–9
stoneware 73

Tang Dynasty 85
Taylor, Lorraine (see Penkridge Ceramics)
Tendelle, Monsieur 9
Theakston, Anthony 31, 109–10
thermal shock 17
thixotropy 71, 72, 82–3
Tiranti, Alec 20
Tschirnhaus, Ehrenfried Walther von 85
turning 34–40

undercuts 44–5, 52, 54

Verdon, Angela 85, 112–13
Vincennes 10, 86

Wardell, Sasha 2, 24, 25, 27, 29, 87, 90, 95, 118–21
warping 88, 90–97, 98
Weiss, Ulrike 39, 107, 109
Whyman, Caroline 71
Wolfe-Murray, Tessa 107–8